TASCHEN
est. 1980

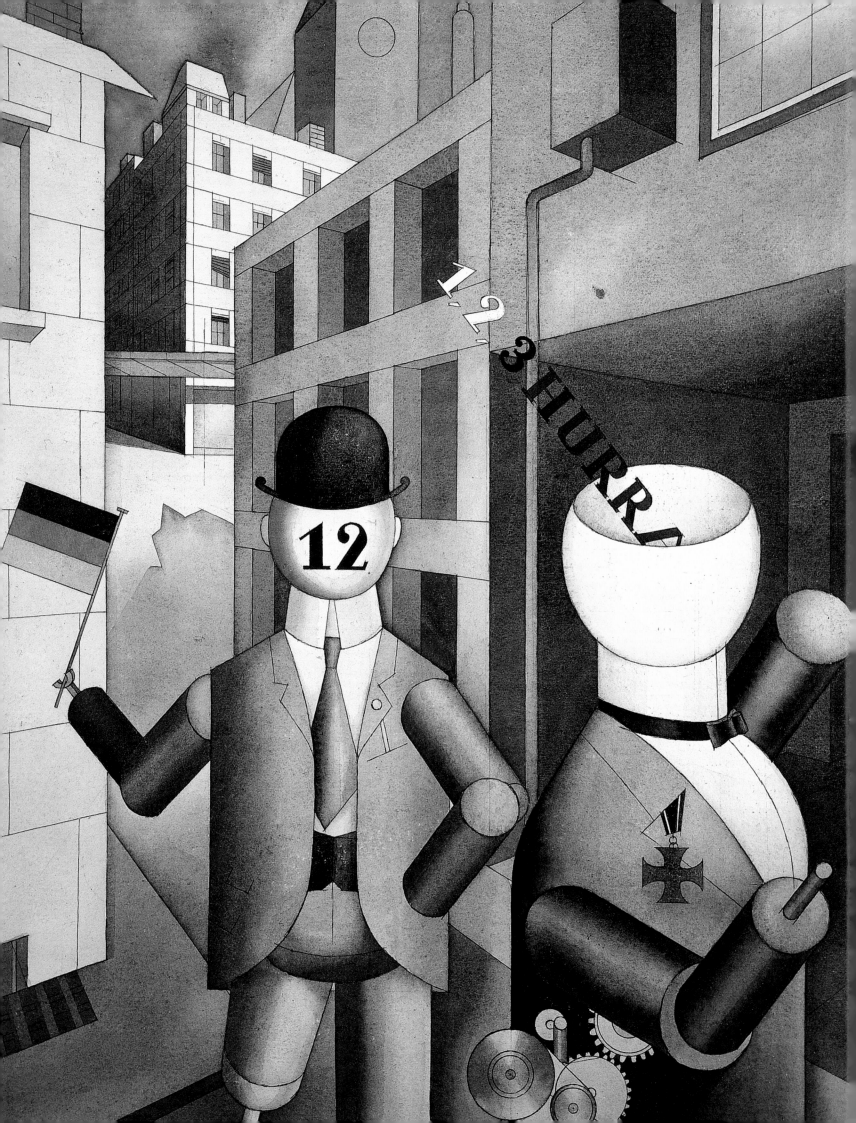

Dadaism

DIETMAR ELGER
UTA GROSENICK (ED.)

TASCHEN

HONG KONG KÖLN LONDON LOS ANGELES MADRID PARIS TOKYO

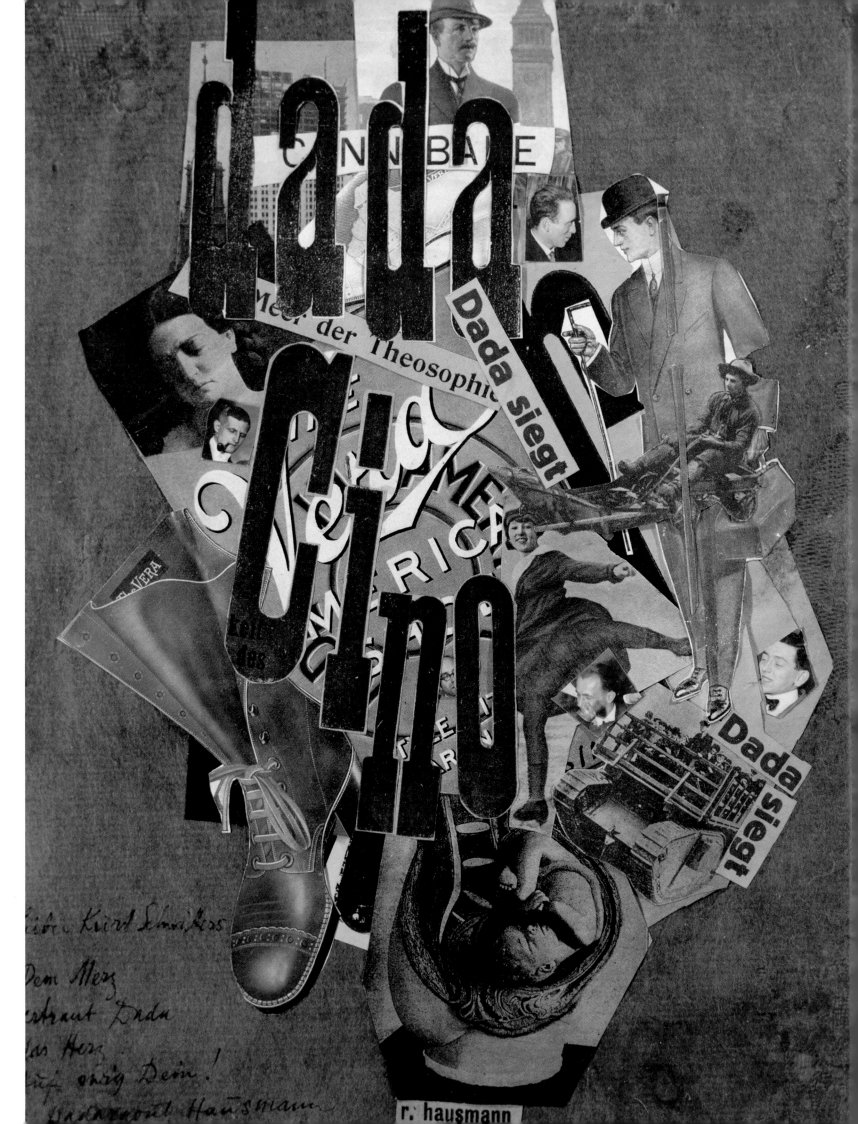

Content

"Before Dada was there, there was Dada"

In its second issue, which appeared in December 1919, the Berlin magazine "Der Dada" asked its readers the question "What is Dada?" and at the same time suggested a series of possible and impossible answers, ranging from "an art" to "a fire insurance". And the questioner finished by asking another question: "Or is it nothing at all, in other words everything?" It was precisely this assessment, one that refused to tie itself down in the slightest, that came closest to the aims and the spirit of Dada. The formulation hints above all at the contradictions which the Dadaists were only too happy to promote. Dadaism was not exclusively an artistic, literary, musical, political or philosophical movement. Indeed it was all of these, and at the same time the opposite: anti-artistic, provocatively literary, playfully musical, radically political but anti-parliamentary, and sometimes simply childish. Many of the Dadaists nurtured their double talents accordingly. As performing artists they were no less committed or inventive than they were with visual techniques.

In spite of the numerous manifestos composed by the Dadaists, there was no tight-knit group behind the movement. Nonetheless, there were those in every town or city who acted as their spokesmen. They provided a focus for their many sympathizers, of whom some in turn took part in Dadaist activities only briefly or occasionally. The period during which the Dada movement was active can be dated approx-imately to the years between the founding of the Cabaret Voltaire in Zurich in 1916 and the early 1920s in Paris, where the movement came to an end. The literati and artists involved were themselves not agreed on when precisely Dadaism ended. Thus the Zurich Dadaist and initiator of the Cabaret Voltaire, Hugo Ball, placed its finale just a few months after its inauguration. However that may be, the movement's appearance and disappearance were above all a reaction to the political situation at the time, to a Europe of hostile nation states, which in 1916 were in the middle of waging a frightful war on each other, and after 1918 created a new political and social order.

Dadaism differed from the various artistic and literary trends in the years immediately preceding – Futurism in Italy, Cubism in Paris and Expressionism in Germany – if in no other way than because it enjoyed broad international support. Artists and men of letters in Zurich, Berlin, Hanover, Cologne, New York, Paris and many other cities were in direct contact with each other, taking part in Dadaist activities and making their own contributions to the movement's numerous publications. In Zurich, the city of Dada's birth, its exponents presented themselves to the public chiefly with literary programmes on the stage. In Berlin, Dadaism also saw itself as a political protest. Cologne's Dadaists by contrast concentrated on the development of new artistic techniques of image creation. Numerous magazines, most

12.1.1916 — Karl Liebknecht is expelled from the SPD (German Social Democratic Party); together with Rosa Luxemburg he founds the Spartacus League on 27.1. **15.1.1916 — The first Orient Express travels from Berlin to Constantinople (now Istanbul)**

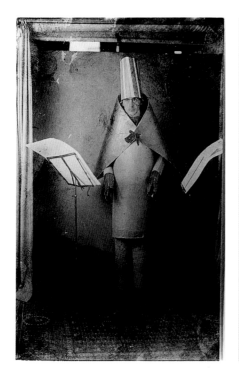

of them short-lived, served not only the purposes of internal communication, circulating between the international Dadaist centres, but also reached a broader public. Thus the "Ventilator" in Cologne had a circulation of 40 000. While the Zurich Dadaists 1916 could attract audiences of several hundred – a respectable enough figure – to their literary evenings, their counterparts in Berlin three years later were filling halls of up to 2 000. And Kurt Schwitters' slim volume of poems "An Anna Blume" went through several editions within a few months in 1919.

The Dadaists were skilled self-publicists. They knew precisely how to keep the expectations of their public on the boil, but it was precisely because these expectations were so high that they eventually failed. Surprise, shock and scandal were deliberately calculated, and the public and the authorities reacted as expected. The Dadaist events provoked the hoped-for protests in the audience, and frequently ended in uproar and tumult. Numerous Dadaist magazines were banned, exhibitions closed, exhibits confiscated, and the artists occasionally arrested. But the more the public came to events with the expectation of being entertained by Dadaist provocation, the more these provocations lost their effect and ran into the ground. Dada's sarcastic laugh, of which the Dadaists liked to speak, was reversed: it was the audience that laughed with pleasure. Dada was ultimately the victim of its own success.

Dadaism was above all the expression of the particular attitude of mind with which international youth reacted to the social and political upheavals of the time. They formulated their opposition in anarchical, irrational, contradictory and literally "sense-less" actions, recitations and visual art-works. On the occasion of the movement's golden jubilee, Hans Arp congratulated it thus: "Bevor Dada da war, war Dada da" (Before Dada was there, there was Dada), thus pointing to two different aspects. Firstly, literati and artists had in earlier comparable situations already had recourse to Dada-like forms of expression. And secondly, every definition of Dada was so vague that it could be stretched to include distant sympathizers and many a fringe figure too, including for example the Dutch De Stijl artist Theo van Doesburg, whose Dadaist manifestation went by the name of I. K. Bonset, or the mysterious and equally pseudonymous Arthur Craven, who published the magazine "Maintenant" in Paris and also made a name for himself as a boxer.

The Dadaists wanted to have an effect in their own time, which was why they emphasized above all the "active" element in their activities. It was for this reason that Tristan Tzara said that Dada demonstrated its truth by its actions. Even so, Dada's spontaneous literary and artistic formulations (and in those days, they were spontaneous) came to occupy a firm historical position and became an important landmark for a younger generation of artists to orient themselves by. If

4.3.1916 — Franz Marc, who had volunteered, falls near Verdun
1.5.1916 — Anti-war rally in Berlin　　　　　　　　　**31.5.1916 — Naval battle at Skagerrak between the English and German fleets**

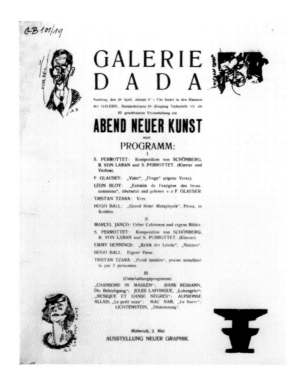

Dadaism today is mentioned in the same breath as other stylistic developments of the first half of the 20th century, such as Expressionism and Surrealism, it is first and foremost because the Dadaist artists and literary figures succeeded in finding pioneering creative processes or further developing existing ones.

Zurich – A Hobby Horse Enters the Stage

In 1916 Switzerland was an island of peace in the midst of the bloody battlefield of the Great War. Young artists, pacifists and revolutionaries from all over Europe found refuge here. It was from his base in Zurich that Lenin laid the groundwork for the Russian Revolution; until April 1917 he lived in the immediate vicinity of the Dadaists' Cabaret Voltaire. In May 1915, Hugo Ball (1886–1927) and his lover Emmy Hennings arrived in the city. He studied philosophy and German literature in Munich, where he had worked at the "chamber theatre" alongside the dramatist Frank Wedekind. In February 1916 Hugo Ball founded the Cabaret Voltaire in Zurich. Those who came to be his most important colleagues in this enterprise were also émigrés, among them Tristan Tzara, Hans Richter, Marcel Janco and Hans Arp. Not long afterwards, Ball also welcomed Richard Huelsenbeck to the group; the two knew each other from time spent together in Berlin. They all had the same reasons for seeking refuge in Switzerland, which Huelsenbeck expressed in the following drastic terms: "None of us had any understanding for the courage that is needed to allow oneself to be shot dead for the idea of the nation, which is at best an interest-group of fur-dealers and leather-merchants, at worst an interest-group of psychopaths, who, from the German 'fatherland', set out with their volumes of Goethe in their kitbags to stick their bayonets into French and Russian bellies."

It was in fact no coincidence that the young literati and artists who started the Dadaist movement in Zurich in 1916 included not a single native-born Swiss. They were brought together here by their detestation of war and their fear of being conscripted to serve at the front. Unlike the Italian Futurist Umberto Boccioni and the German Expressionists Max Beckmann, August Macke and Erich Heckel, they never fell for the naive temptation to transfigure the War into some kind of heroic community experience for the youth of Europe. Franz Marc was another who, to start with, saw the War as the great event that would renew society: "That Augean stable, old Europe, could not be cleansed in any other way," he wrote to his friend Wassily Kandinsky on 26 September 1914, "or is there a single person who wishes this war had never started?" From the very outset, Hugo Ball

14.7.1916 — The French President Raymond Poincaré demands the return of Alsace-Lorraine as proviso for a ceasefire
5.11.1916 — Germany and Austria proclaim an independent Kingdom of Poland

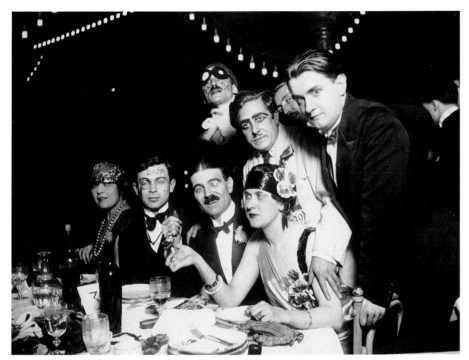

5

was much more critical of this blind enthusiasm. "What has now broken out is the total machinery and the Devil himself. The ideals are mere fig-leaves," he noted in his diary in November 1914. Six months later he fled to Switzerland. When he opened his Cabaret Voltaire in February 1916, Boccioni, Macke and the Expressionist poet August Stramm had already been killed in action. The Western Front had got bogged down into unrelenting trench warfare. Not long afterwards, on 4 March 1916, Franz Marc was killed at the Battle of Verdun, which claimed the lives of more than 700 000 French and German soldiers.

The Dadaists reacted with horror and disgust to the brutality of the war, to the mechanical anonymous killing, and to the cynical justifications put forward by the powers-that-be on both sides, who sought to use the seeming logic of their arguments to legitimize their war policy. The Dadaists accused the public in the belligerent nations of a deferential, nationalist attitude. They formulated their own position with corresponding self-confidence. "Dada wanted to destroy the deceptions of reason and discover an irrational order," was how Hans Arp characterized their goal. To achieve it, however, the Dadaists used very different methods. While the Berlin group also took part in political debate in an attempt to activate their public to think and act for themselves, the Zurich Dadaists relied solely on irony, irrationality and the shock-effect of their literary provocations.

Hugo Ball himself had lively memories of the foundation of the Cabaret Voltaire: "I went to Mister Ephraim, the owner of the 'Meierei' and said: 'Please, Mister Ephraim, can I have your hall?' And I went to various friends and said: 'Please, can I have a drawing or a print? I'd like to combine my cabaret with a little exhibition.' I went to the friendly Zurich press and asked them: 'Write a few notices. It's planned to be an international cabaret. We're planning to do some nice things.' I got the pictures and the notices. And so on 5 February we had a cabaret." The modest hall at no. 1 Spiegelgasse had enough room for a little stage and about fifty guests. The walls were decorated with works by Max Oppenheimer and Hans Arp and masks by Marcel Janco. Every evening, Ball and his friends staged a varied programme of songs, readings, music and dances. The opening was accompanied by pieces he had written himself, along with texts by Frank Wedekind, Alfred Jarry, Guillaume Apollinaire, and not least, by the club's "patron saint", the French Enlightenment philosopher Voltaire. The musical accompaniment consisted of pieces by Debussy and Ravel. The dance numbers were performed by members of the Laban School, directed by the choreographer Rudolf von Laban, which had been evacuated from Munich, and the dancers included Mary Wigman, Sophie Taeuber and Ball's partner Emmy Hennings. The masks and costumes for the exotic dances were designed by Marcel Janco and Hans Arp respectively.

--

7.11.1916 — Thomas Woodrow Wilson is re-elected President of the United States

1917 — Poor food supplies and extreme temperatures lead to the "Turnip Winter" in Germany

--

> "Dada for me was a new beginning and a closure. In free Zurich where the newspapers can say what they want, where magazines were founded and poems against the war read out, here where there were no ration-cards and no 'ersatz', here we had the possibility of shouting out everything that was filling us fit to burst."
>
> Richard Huelsenbeck

6

7

For Zurich, the programme for the first few months was something new, though it was by no means unusual by international standards. Hugo Ball had already organized similar soirées in Berlin together with Richard Huelsenbeck. Nor can it be said that the first events were typically Dadaist in character. The poems and texts were still geared to the familiar pathos and power of language of Expressionism. Only gradually, and driven by the heightened expectations of the audiences, did the organizers grow more courageous, venturing to do new things. The news that filtered from the fronts across the borders to peaceful Zurich could only encourage them in their enterprise: there was method in the madness. The total rejection of all rules and the breach of all existing barriers seemed now to be the only appropriate response to this war. Hugo Ball described this radicalization of the programme as follows: "Our attempt to entertain the public with artistic things pushes us, in a manner which is as instructive as it is stimulating, towards the uninterruptedly lively, new and naive. It is a race with the public's expectations, which demands all our powers of invention and argument." The "performers" found new forms of literary expression in meaningless phonetic sound-poems and the so-called simultaneous poems, where all the performers on the stage read their texts at the same time. The artists appropriated the collage technique invented by the Cubists Pablo Picasso and Georges Braque in France. All they needed was a correspondingly forceful name: DADA!

Few if any other movement-names have generated so many myths. Several Dadaists claim to have discovered or invented it. Friends supported now one version, now the other. In the battle of priorities – and not just in the disputes concerning the origin of the word Dada – most Dadaists suddenly became deadly serious. Among the Parisian group in the early 1920s, the honours were accorded to Tristan Tzara. Following his return from Zurich in January 1920, he had claimed to have found the term Dada in the Larousse Dictionary. When rumours suddenly sprang up that Hans Arp was the only begetter, however, Tzara is even said to have forced a denial out of him, which then appeared in 1921 in the magazine "DADA": "I hereby declare that the word Dada was discovered by Tristan Tzara at six o'clock in the afternoon of 8 February 1916; I was present with my twelve children when Tzara first pronounced the word, which naturally filled us all with enthusiasm." Later Hans Arp was moved to deny the suggestion that his very choice of words was enough to reveal the ironic nature of this statement. In fact, many Dadaists seem to have believed that his declaration did indeed constitute a confirmation of Tzara's claim. In 1921 the future Neue Sachlichkeit painter Christian Schad, who worked with the Dadaists for a short time, became an-

1917 — **Submarine warfare intensified against Britain in favour of his brother Mihail (1878–1918). The Russian Duma proclaims the formation of civil government**

15.3.1917 — Tsar Nikolai II abdicates in

6. GEORGE GROSZ

<u>Untitled</u>
1920, oil on canvas, 81 x 61 cm
Düsseldorf, Kunstsammlung
Nordrhein-Westfalen

7. GEORGE GROSZ

<u>A Victim of Society (Remember
Uncle August, the Unhappy Inventor)</u>
1919, oil, pencil and collage on canvas,
49 x 39.5 cm
Paris, Musée National d'Art Moderne,
Centre Pompidou

8. GEORGE GROSZ

<u>Dada-picture</u>
c. 1919, pen and ink, photo and
text collage, 37 x 30.3 cm
Zurich, Kunsthaus Zürich

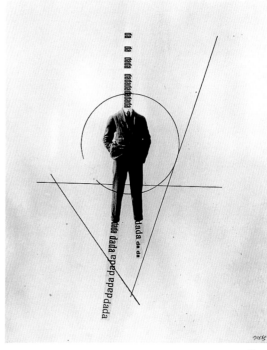

8

other who felt obliged to set the record straight concerning the chronology of events. In a letter to Francis Picabia in Paris he wrote: "So here is what I have found out and what every German or Swiss writer will tell you if you ask him. The word Dada was found by Mr Hülsenbeck and Mr Ball. There are numerous witnesses who will testify that Mr Tzara was somewhere completely different at the time."

The most credible version is indeed the one which Richard Huelsenbeck himself put about in his book of memoirs "En avant Dada": "The word Dada was discovered by chance by Hugo Ball and me in a French-German dictionary while we were looking for a name for Madame le Roy, the singer at our cabaret. Dada means hobbyhorse in French. We were impressed by its brevity and suggestivity, and in a short time dada became the label for all the artistic activities we were engaging in at the Cabaret Voltaire." The term is first publicly documented in the preface to the first edition of the magazine "Cabaret Voltaire", which appeared at the end of May 1916, in which Ball reports on the foundation of the Cabaret, and goes on to announce: "The next goal of the artists assembled here is the publication of a Revue Internationale. La revue paraîtra à Zurich et portera le nom 'Dada'. ('Dada') Dada Dada Dada Dada." He had already used the word a couple of times in private diary entries the previous month. In this naive babytalk, the Dadaists found an appropriate expression

for their nihilism, their disgust at all bourgeois convention and at the warmongering of the politicians. In its combination of onomatopœic conciseness on the one hand and freedom from interpretable meaning on the other, the term seemed to be a good war-cry in their assault on the traditions of literature and art, as well as on the harmonious order of composition, colour theory and prosody. While the Dadaists could not abolish war, the political power structures, or the class system in society, they could make their point by smashing the formal structure of pictures and poems. It was only in Berlin that the Dadaists, under the leadership of Richard Huelsenbeck, George Grosz and John Heartfield, turned this literary and artistic proxy-war into an active political struggle.

A typical appearance by Hugo Ball on the stage of the Cabaret Voltaire at no. 1 Spiegelgasse in Zurich is indicative of what the audience had to prepare themselves for. In his own words: "I wore a costume specially designed by Janco. My legs were covered in tubes of luminous blue cardboard which reached to my hips." Round his shoulders, Ball wore a broad collar, on his head a stovepipe hat. Marcel Janco had made the costume from cardboard. The collar and hat were gold and shiny, making him look rather like a Cubist sculpture. In this get-up, Hugo Ball presented himself to his audience as a high priest of Dadaism, and when after a short pause he embarked on his

6.4.1917 — USA enters the war against Germany
17.5.1917 — Russian revolutionary Leon D. Trotsky returns to Russia after a period of U. S. exile

11

gadji beri bimba glandridi laula lonni cadori
gadjama gramma berida bimbala glandri galassassa laulitalomini
gadji beri bin blassa glassala laula lonni cadorsu sassala bim
gadjama tuffm i zimzalla binban gligla wowolimai bin beri ban
o katalominai rhinozerossola hopsamen laulitalomini hoooo
gadjama rhinozerossola hopsamen
bluku terullala blaulala loooo

Hugo Ball, "Gadji beri bimba", first verse

9

recitation, the amazement of the visitors in the hall developed into a raging storm of protest. He began his performance with the following lines, spoken in a loud voice: "Gadji beri bimba/glandridi lauli lonni cadori/gadjama bim beri glassala/glandridi glassala tuffm i zimbrabim/blassa galassasa tuffm i zimbrabim…"

Hugo Ball was the inventor of these sound-poems, which became the preferred form for Dadaist stage-artists. In the sound poem, traditional order, the interplay of sound and meaning, is abolished. The words are dissected into individual phonetic syllables, thus emptying the language of any meaning. Finally, the sounds are recombined into a new sound-picture. This process robs language of its function. Because, in the view of the Dadaists, instructions, commands and the conveyance of information had deprived language of its dignity. "With these sound-poems," said Hugo Ball in justification of their intentions, "we wanted to dispense with a language which journalism had made desolate and impossible." Instead, the Dadaists sought to restore words to their pristine innocence and purity. Other Dadaists sought to aestheticize their text material by arranging the syllables in such a way as to produce music-like sound-picture verse-compositions through repetition and rhythm. And in fact the Hanover Dadaist Kurt Schwitters did succeed, over a period of ten years, in advancing from such modest beginnings to compose a forty-minute

sound-picture "Sonate in Urlauten" (Sonata in Elemental Sounds), which was structured in a number of movements to which classical tempo indications such as rondo, scherzo and presto were assigned.

These literary and musical experiments culminated in the so-called simultaneous poems, which were recited by several people at once, the various contributions producing a frenetic confusion of voices which could be interpreted as symbolic of the deafening background of noise in the trenches and of the dynamics of modern urban society. The simultaneity of these impressions, the large-format advertising hoardings, the speed and noise of technological forms of transport: these were already the themes of the Italian Futurists. In 1911, their spokesman Umberto Boccioni painted the movement's programmatic picture *The Noise of the Street Invades the House*. However, the Dadaists were disgusted by the Italian Futurists' enthusiasm for technology when applied to modern war machines. Mechanical Dadaist constructions, as designed by, among others, Raoul Hausmann, Max Ernst, Francis Picabia and Kurt Schwitters, were never anything but functionless, ironic or erotic.

Another literary technique widely employed by the Zurich Dadaists at the Cabaret Voltaire was the "random poem". As the name suggests, the random principle plays a decisive role in the production of such a poem. It allowed the Dadaists to reduce their creative influ-

19.6.1917 — Suffrage for women aged 30 and over is introduced in the U. K.

15.10.1917 — Dancer Mata Hari is executed in Paris on account of alleged espionage for Germany

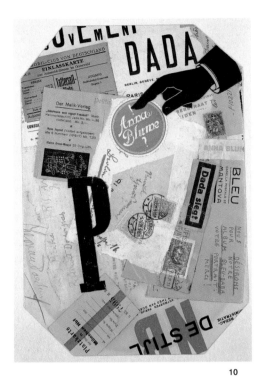

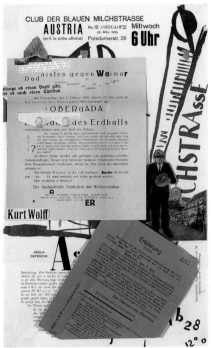

10

11

9. AUGUST SANDER
<u>The Dadaist Raoul Hausmann</u>
1928, photograph, 25.1 x 17.6 cm
Zurich, Kunsthaus Zürich

10. RAOUL HAUSMANN
<u>P</u>
1921, collage, 32.2 x 22.5 cm
Hamburg, Hamburger Kunsthalle

**11. JOHANNES BAADER AND
RAOUL HAUSMANN**
<u>Dada Milky Way</u>
c. 1919/20, collage on poster by Raoul Hausmann,
50.4 x 30.7 cm
Zurich, Kunsthaus Zürich

ence to just a few predefined inputs. In 1916, Tristan Tzara came up with a graphic instruction for the production of such poems: "In order to make a Dadaist poem, take a newspaper. Take a pair of scissors. Choose an article of the length of the intended poem. Cut the article out. Then cut out each of the words which comprise the article, and put them in a bag. Give the bag a light shake. Then take out one snippet after another, just as they come. Write everything down conscientiously. The poem will be similar to you." The example which Tzara then quotes as a result of such a process, however, cannot have arisen randomly in this way. It begins with the words: "Wenn die Hunde die Luft kreuzen in einem Diamanten wie die Ideen und der Fortsatz der Hirnhaut die Stunde des Erwachens eines Programms zeigt…" (When the dogs cross the air in a diamond like the ideas and the process of the meninges shows the hour of the awakening of a programme…). What makes his instructions so exciting, nevertheless, is the fact that here for the first time a procedure is being described which was to leave its mark on the artistic process in the coming decades. The Dadaists were not so much the inventors as the recyclers of existing (everyday) materials, to which they then gave aesthetic form. In the techniques of collage and photomontage, the visual artists of the 20th century had recourse time and again to similar techniques of picture production.

In Zurich, the dynamics of the Dadaist movement soon began to display symptoms of dissolution. While all the Dadaists had still taken part in the 1st Dada Soirée on 14 July 1916, the event did not take place in the Cabaret Voltaire, but in the Zur Waag guildhall. Just two weeks later, Hugo Ball left the city and withdrew temporarily to Ticino. In his diary he noted at the time, in respect of the event of 14 July: "My manifesto for the first soirée was a barely concealed rejection of my friends. That's how they received it, too. Have you ever known a new cause's first manifesto to rebut that cause in the presence of its adherents? And yet that's how it was. When things are exhausted, I cannot stay with them any longer." However the other Zurich Dadaists continued their activities and events with unbroken energy under the leadership of Richard Huelsenbeck and Tristan Tzara.

Nonetheless, when the Galerie Dada was set up in March 1917, Hugo Ball was involved once more. Albeit belatedly, the Dadaists thus seemed to concede that the visual arts should at last be accorded more importance in their movement. The programmatic orientation of the inaugural exhibition sought above all, however, to link up with the roots of literary Dadaism. On view were works by Expressionist artists associated with the gallery Der Sturm, which were accompanied by a Sturm soirée with literature and music by Alban Berg, Wassily Kandinsky, Arnold Schönberg and Paul Scheerbart.

7.11.1917 — October Revolution in Russia; the victorious revolutionaries form a Government of People's Representatives under the chairmanship of Vladimir I. Lenin **10.12.1917 — The International Committee of**

12.
"First International Dada Fair"
Catalogue, 1920, with texts by Wieland Herzfelde
and Raoul Hausmann
Berlin, Berlinische Galerie, Landesmuseum für
moderne Kunst, Photographie und Architektur

13.
"First International Dada Fair"
July 5, 1920, gallery Dr Burchard, Berlin, Berlinische
Galerie, Landesmuseum für moderne Kunst,
Photographie und Architektur
From left to right, standing: Raoul Hausmann, Otto
Burchard, Johannes Baader, Wieland and Margarete
Herzfelde, George Grosz, John Heartfield; seated:
Hannah Höch, Otto Schmalhausen

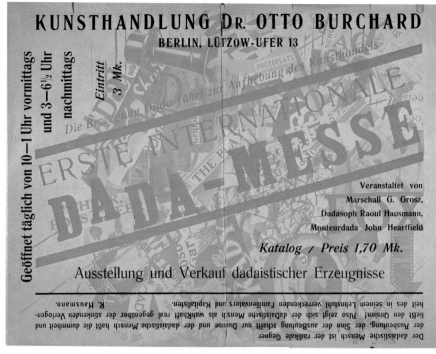

12

In spite of the participation of Hans Arp and Marcel Janco in the Zurich Dada movement, the mood among the literati involved was basically anti-artistic. They were prepared to allow the visual arts some entitlement to a place in the Dadaist movement, if at all, only if they proved themselves radically anti-aesthetic and ahistorical, and liberated from all art-historical role-models. A renunciation of traditional work in oils on canvas on the part of the visual artists was one of the consequences of satisfying such demands by their fellow-Dadaists. If the Dadaist artists did re-work familiar motifs from art-history and integrate them into their own works, then it was always with a disrespectful undertone.

1917 was not out before Hugo Ball withdrew to Ticino once more. Hans Arp left Zurich in 1919. He went first to Cologne, where he met up with Max Ernst again, and together with him and Johannes Theodor Baargeld established the Cologne Dadaist group. Richard Huelsenbeck had already returned to Germany in January 1917 in order, together with like-minded persons in Berlin, to breathe new life into the Dadaist idea. After his friends had left, it was Tristan Tzara who became the sole spokesman of the movement in Zurich. In the next two years, he organized further evenings and published among other things the magazine "Der Zeltweg". The young author Walter Serner was his most important colleague at this time. Dadaism came to an end in Zurich at the latest with Tzara's departure for Paris in January 1920. By this time Dadaism had only just reached the climax of its international triumphal march through Berlin, Paris and New York, as well as less metropolitan locations such as Hanover and Cologne.

Berlin – "Dada is: a flourishing business"

As a medical student in Berlin, Richard Huelsenbeck (1892–1974) had made contact with the local literary Expressionist scene before the First World War. His later Dadaist appearances were once described by Hans Richter in the following terms: "He is regarded as arrogant, and that's also how he looks. His nostrils vibrate, his eyebrows are arched." At the start of 1917, Huelsenbeck returned from neutral Switzerland to Berlin, where at first he joined the literary circle centred on the magazine "Neue Jugend" (New Youth). In May that year he published his anthem "Der neue Mensch" (The New Man). The magazine's title and his own contribution are still characterized by the verbal exuberance of the Expressionists: "The new man must spread wide the wings of his soul, his inner ears must be aimed at things to come and his knees must invent an altar before which

the Red Cross is awarded the Nobel Peace Prize

17.7.1918 — Tsar Nikolai II. and his family are shot by Bolshevists in Ekaterinburg

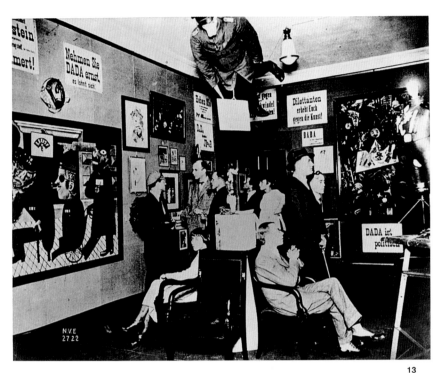

"What we call Dada
is a piece of tomfoolery
from the void, in which
all the lofty questions have
become involved ..."

Hugo Ball

13

they can bend," is just one pathos-filled example. There is suddenly no sign here of the ironic playing with words that was so characteristic of Zurich Dadaism. Huelsenbeck had, as he later himself confessed, temporarily parted company with Dadaism. Indeed, it took a whole year for him to renew his public commitment to the movement with an appearance at the Graphisches Kabinett I.B. Neumann on 22 January 1918. That evening he ignited the spirit of Dada in Berlin with a fire-raising speech. His ideas were spontaneously and enthusiastically taken up in the Reich capital by numerous young literati and artists. "He carried the Dada bacillus to Berlin, where Raoul Hausmann, already infected from birth, was so receptive to the infection that came from Zurich that the bacilli themselves didn't know whether they descended from R.H. or R.H. on their father's side," was how Hans Richter appraised Huelsenbeck's importance as the midwife of Berlin Dadaism.

The difficult living conditions and the chaotic political situation in Germany had deteriorated still further by the beginning of 1918. In the cities, the people were starving, and following the end of the battles in Flanders in November the previous year, the whole extent of the slaughter in the trenches, which had claimed hundreds of thousands of lives, was slowly becoming obvious. There was very little left of the initial enthusiasm for the war in the population at large. Gradually, Germany began to see the first signs of protest against the

official admonishments to hold out. The so-called "January strike" in Berlin in 1918, in which more than 400 000 workers had taken part, finally triggered demonstrations throughout Germany. The atmosphere intensified with the armed naval mutiny in Kiel in November. Berlin and other major cities saw the formation of workers' and soldiers' councils on the Soviet model, their example being followed by committed artists who formed a "working council of art", whose members included the Expressionist painters Otto Mueller, Emil Nolde and Karl Schmidt-Rottluff, along with the architects Bruno Taut and Walter Gropius, the founder of the Bauhaus in Weimar. The Berlin Dadaists by contrast formed their own movement.

"This evening," confidently proclaimed Richard Huelsenbeck in January 1918 in the Kunstkabinett I.B. Neumann, "is intended as a demonstration of sympathy for Dadaism, a new international 'artistic trend', which was founded two years ago in Zurich." In the following months, he was joined by, among others, Johannes Baader, George Grosz, Raoul Hausmann, Hannah Höch and John Heartfield. The onomatopœic term Dada seemed to give expression to their unease at the social situation in Germany, and in the activities of the Zurich group they found pre-formed possibilities of giving artistic form to their protest. For 12 April 1918 Huelsenbeck and Raoul Hausmann organized a recitation evening at the Berlin Sezession, where Richard

28.10.1918 — The Czechoslovakian state is proclaimed in Prague
3.11.1918 — Sailor's Uprising in Kiel
9.11.1918 — Kaiser Wilhelm II. abdicates and goes into exile in the Netherlands. Philipp Scheidemann proclaims the republic

15

14.

<u>"First International Dada Fair"</u>
Opening, 1920
Berlin, Berlinische Galerie, Landesmuseum für
moderne Kunst, Photographie und Architektur
From left to right: Hannah Höch, Otto
Schmalhausen, Raoul Hausmann, John Heartfield
(hidden) with son Tom, Otto Burchard, John
Heartfield's wife Lena, Wieland Herzfelde, Rudolf
Schlichter, the architect Mies van der Rohe,
unknown, Johannes Baader; on the large photo-
graph: George Grosz

15.

<u>Dada Almanac</u>
1920, 18.3 x 13.3 cm, 160 pages, "commissioned by
the Central Office of the German Dada Movement,
edited by Richard Huelsenbeck"

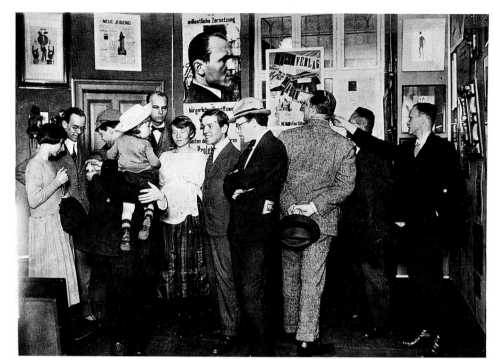

14

Huelsenbeck intended to proclaim the first manifesto of the Berlin movement and announce the establishment of the Club Dada. His address, entitled "Dadaism in life and art", took the form, to start with, of a polemic directed against German Expressionism, before going on to emphasize the special features of Dada: "By shredding all the slogans of ethics, culture and inwardness, which are only cloaks for weak muscles, Dadaism is for the first time not confronting life aesthetically." As examples of the creative means it used, Huelsenbeck adduced the bruitist, simultanistic and static poem, as well as "the use of new material in painting", in other words the deployment of collage and photomontage for artistic purposes. The "Dadaist Manifesto" ends by noting: "Being against this Manifesto means being a Dadaist!" As with the Zurich Dadaists, contradiction and illogicality were to be among the hallmarks of Berlin Dadaism too. The same evening saw the recitation of the first examples of Dadaist verse – or would have done, had they not been drowned in the tumult of the outraged public. The event had to be brought to a premature end.

The printed copies of the Manifesto, which the businesslike Huelsenbeck had signed with the intention of selling them for five marks each, were confiscated by the police. Three days after the event, Raoul Hausmann was taken temporarily into custody. The Dadaist onslaught in Berlin thus received a major setback right at the

outset, from which the group was not to recover until the end of the year. Even so, Hausmann judged the evening to have been a success. He reported proudly to his lover Hannah Höch: "For 22 marks in cash, until 27 April we kept the newspapers in such suspense that they provided our publicity." Following Huelsenbeck's first appearance in Berlin, two years passed before the Dadaists finally formed a closer association in early 1919 and began to turn to a broader public with numerous activities and publications. The trigger, according to Raoul Hausmann, was the murder of the leading Communists Karl Liebknecht and Rosa Luxemburg on 15 January 1919. "The proletariat was paralyzed and could not be shaken out of its narcosis. So we had to intensify the DADA actions: against a world which could not even react manfully to unpardonable horrors," he recalled in his book "Am Anfang war Dada" (In the Beginning was Dada).

Richard Huelsenbeck could still describe Dada in April 1918 as a club which anyone could join without obligation, but the choice of words now became more aggressive and the club more exclusive. No way were they going to continue to accept any applicant as member, least of all Kurt Schwitters from Hanover. The rivalries between existing Dadaists also intensified, and the name they chose for themselves now, borrowed from the revolutionary political soviets, had more than just a satirical function. The Berlin Dadaists now met under the insti-

11.11.1918 — Surrender of the German Reich. Signing of the ceasefire
30.11.1918 — Publication of Heinrich Mann's novel "The Man of Straw"

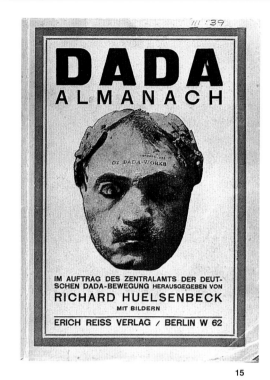

"DADA means nothing.
We want to change the
world with nothing."

Richard Huelsenbeck

tutional title "The Dadaist Central Council of the World Revolution". Huelsenbeck's letter-head identified him as "Central Councillor of the Dadaist Movement in Germany", while Johannes Baader had himself addressed as "President of the Globe", and Raoul Hausmann's visiting card suggested that he was the "President of the Sun, the Moon and the Little Earth (Inner Surface)". In addition they bestowed so-called titles of honour upon each other, which they all bore with a certain pride: Richard Huelsenbeck who had arrived from Zurich was respectfully referred to as "Weltdada" (World Dada), while Hausmann was the "Dadasopher" and his lover Hannah Höch the "Dadasophess".

Even though all the manifestos and proclamations were signed jointly by all the Dadaists, most of the projects continued to be individual activities. The members of the Club Dada, who urged the leading representatives of politics and society in the German Reich to embrace anarchy, themselves embraced its practice enthusiastically within their own group. Egomania and petty jealousies among its members led to constant disputes. Fifty years later, Raoul Hausmann could still vividly recall these ideological battles: "Heartfield-Herzfelde and Mehring worshipped George Grosz, that pseudo-revolutionary, Huelsenbeck worshipped only Huelsenbeck; although he had produced most of our twelve events together with me, he was always ready to incline towards the Groszists. Conversely I tended to side with Baader, who unfortunately was too often obsessed with his paranoid religious ideas."

Dada Berlin evinced a more aggressive expression than its exemplar in Zurich. While the Swiss model was basically a literary cabaret, with a few anarchist features, the Club Dada adopted explicitly political attitudes. The Zurich people expressed their disgust with political events by radically rejecting any attitude of their own and retreating to a nihilist position. By contrast, the Berlin Dadaists formulated opposition to the war, the Weimar Republic, the Prussian bureaucracy, and the conservative bourgeoisie in numerous polemical proclamations, manifestos and public events. Their most important communication organs were the numerous little Dadaist magazines which admittedly vanished after just a few numbers. These included "Der Dada", edited by Raoul Hausmann, "Die freie Strasse" (The Open Street), which he edited jointly with Johannes Baader, and "Der blutige Ernst" (Deadly Serious) and "Die Pleite" (Bankrupt). In addition, the Berlin Dadaists repeatedly succeeded in interesting the major daily newspapers in their activities, and in getting them to support their goals. Huelsenbeck, Hausmann, Baader, Grosz and Heartfield proved to be skilful publicity strategists, pastmasters in the art of drumming up support. "Dada conquers" and "Join Dada" were just two of the pithy slogans which they repeatedly employed in a variety of

3.12.1918 — Founding of the artist's associate "The November Group", which included among others Max Pechstein and the architect Erich Mendelsohn **1.1.1919 — Introduction of the eight-hour day in Germany**

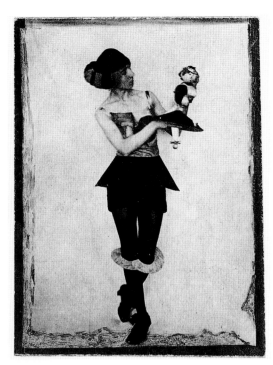

16.

<u>Hannah Höch as one of her figurines</u>
c. 1925, photograph
Berlin, Berlinische Galerie, Hannah Höch-Archiv

17.

<u>Dada conquers!</u>
1920, exhibition poster for the re-opening of the "Dada
Pre-Spring" exhibition at Schildergasse 37 in Cologne,
after it was closed by the police, 28.7 x 40 cm
Zurich, Kunsthaus Zürich

18.

<u>Richard Huelsenbeck and Raoul Hausmann in Prague</u>
1920, photograph from the "Dada Almanac"
Zurich, Kunsthaus Zürich

16

"Art is dead.
Long live Dada!"
Walter Serner

contexts. In 1920, the five protagonists of the movement even formed a Dada Advertising Company, which doubtless never won any commercial contracts. The Berlin Dadaists had an eye for business in other respects too. They had Dada Tours, which they used to take their ideas and activities to other cities, organized by large event agencies. Tristan Tzara could thus say in 1920 without a trace of irony: "Dada is: a flourishing business."

The attacks of the Berlin Dadaists on the political system were often acerbic in the extreme. They even threatened the destruction of the Weimar Republic: "We will put a bomb under Weimar. Berlin is the Dada Place. No one and nothing will be spared." Or they offered their services to revolutionary and separatist groups: "The Club Dada has set up a bureau for separating states. Fixed price-list for state-formation according to scale of operation." In impressive fashion, a large-format collage by Hannah Höch dating from 1920 describes better than any other work the mood of the times and the political direction Berlin Dadaism was taking. Its telling title: *Incision with the Dada kitchen knife through Germany's last Weimar beer-belly cultural epoch.*

The Berlin group extended Dadaist imagery by taking up the photomontage technique, which, though unknown in Zurich, had important precursors among the Russian Constructivists and Italian Futurists. This technique extended the familiar collage by including photographic fragments, the realism of which imported a new degree of provocation into the genre. Compared with drawings and paintings, however realistic, a photograph is always more credible. In combination with other, typographical design elements, such as newspaper cuttings and printed headlines, photomontage conveys a dynamism, immediacy and actuality impossible in all other means of artistic expression. The rapidity made possible by the use of scissors and paste was just what the Berlin Dadaists were looking for. After all, most of their photomontages were not designed as autonomous works of art, but as posters, book covers, or as illustrations to accompany newspaper articles or advertising copy.

In view of the Dadaists' numerous spectacular actions and manifestos, it seems all the more surprising that it was precisely a somewhat traditional exhibition in the premises of an established art-dealer that both marked the culmination of the movement in Berlin and at the same time ushered in its end. The "First International Dada Fair", which was held in the rooms of the art-dealer Dr Otto Burchard from 30 June to 25 August 1920, remains the only attempt ever undertaken by the Dadaists to document the global character of their movement by means of an exhibition. The catalogue published to accompany it listed 174 works created by the widest-possible variety of techniques. The organizers of the Dada Fair were the Propagan-

15.1.1919 — Karl Liebknecht and Rosa Luxemburg are murdered
18.1.1919 — Beginning of the Paris Peace Conference, allies form the League of Nations on 25.1.

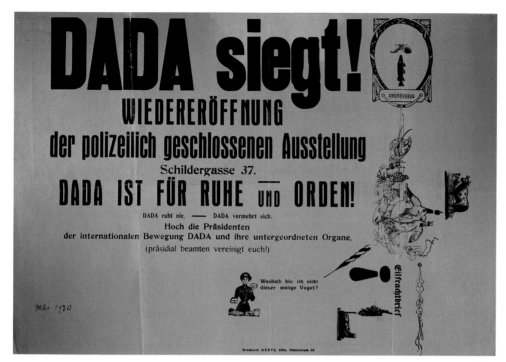

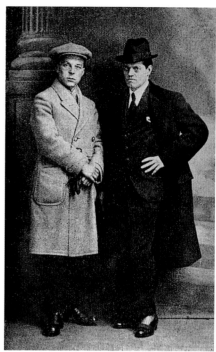

17

18

dada Marshal George Grosz, the Dadasopher Raoul Hausmann and the "Monteurdada" (Mechanic Dada) John Heartfield. The gallery-owner Otto Burchard not only made his rooms available, but also gave financial support to the enterprise, a gesture which moved Richard Huelsenbeck to bestow on him the honorary title of "Finance Dada".

On the surviving photographs of the exhibition it is possible to discern, among other things, posters with various Dadaist slogans: "Dilettantes! Rise up against art!", "Take Dada seriously, it's worth it", and "Dada is political". The photographs capture very well the atmosphere of the exhibition. The walls of both rooms in the gallery and in the connecting corridor are hung with every kind of exhibit cheek-by-jowl. In the middle of one room stands the splendid construction by Johannes Baader *The Great Plasto-Dio-Dada-Drama*, described in the catalogue as "Dadaist Monumental Architecture". From the ceiling of the other hall, John Heartfield and Rudolf Schlichter have suspended a tailor's dummy in officer's uniform and a pig mask. This exhibit later resulted in prosecution on a charge of "insulting the German army".

While the exhibition focused on Dada Berlin, many others also took part, including Hans Arp from Zurich, Otto Dix from Dresden, Francis Picabia from Paris, Max Ernst from Cologne, and Otto Schmalhausen from Antwerp. One man conspicuous by his absence was Kurt Schwitters from Hanover. But the "Dada Fair" did include a

contribution by Rudolf Schlichter, which bore the title *The Death of Anna Blume*, a malicious allusion to Schwitters' popular poem "An Anna Blume". The "Dada Fair" had plenty of other provocative material on offer besides. But the public showed little interest, and there was no scandal. "They exhibited every possible boldness in respect of material, opinion, invention – unparalleled even by today's Neo-DADA or Pop Art – but the public wouldn't play along, no one wanted to see Dada any more," was Raoul Hausmann's sober résumé of the event many decades later.

Notwithstanding, Hausmann believed even before the exhibition opened that he could predict the press criticism, and thus published a parody of the expected reviews in the accompanying catalogue. Under the title "What the art critics will, in the opinion of the Dadasopher, say about the Dada exhibition", he wrote: "Let us establish at the outset that this Dada exhibition is a perfectly ordinary bluff, an unworthy speculation on the curiosity of the public – it is not worth coming to see it." A few lines later, he enlarges on the matter as follows: "Nothing they do can surprise us any more; everything is submerged in spasms of originality, which, devoid of any creativity, simply lets off steam in absurd antics." And indeed, the review penned by the publicist and satirist Kurt Tucholsky for the "Berliner Tageblatt" newspaper read as follows: "If we discount that part of the club's activities

6.2.1919 — Social Democrat Friedrich Ebert is elected as first Reichs President

16.2.1919 — Free elections in Germany and Austria March 1919 — Founding of the Bauhaus in Weimar by the architect Walter Gropius

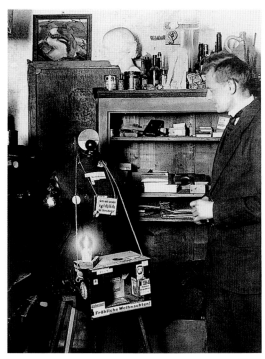

19 20

which are pure bluff, there is not so awfully much left… It is pretty quiet in this little exhibition, and no one actually gets worked up any more." And he ends with the telling word-play: "Dada – na ja." (Dada, oh well…) So the charge of insulting the German army became the Berlin Dadaists' final triumph and a confirmation that they still had the capacity at least to annoy and provoke the authorities. The result of the subsequent trial in April 1921 was, however, sobering. The charge against Hausmann was dropped completely. Baader, Burchard and Schlichter were acquitted. Only George Grosz and Wieland Herzfelde were convicted, and given trivial fines. The court judged the figure entitled *Prussian Archangel* hanging from the ceiling and Grosz' folder of prints entitled *God With Us* as nothing more than bad jokes in poor taste. The artists' defending counsel had argued thus himself – with devastating consequences, as Raoul Hausmann noted in retrospect: "His closing address saved Grosz' skin, but demolished him and his friends. Is this what your defence looks like: You didn't really mean it?" At the very moment Dada was really taken seriously by the powers that be, and was hauled up before the law to answer for its actions, the Dadaists got cold feet.

However, by this time the Berlin Dadaist movement was already in a state of dissolution. Heartfield, Hausmann, Baader and Grosz were beginning to go their own separate ways. As late as 1920,

Richard Huelsenbeck had published a number of tracts which already sought to draw up a balance-sheet regarding the achievements of the Dada movement: "Germany must sink. Memoirs of an old Dadaist revolutionary" was the title of one of these books, and it was not intended ironically. "The victory of Dada. A balance-sheet of Dadaism" was another. In fact, the anti-art of Dadaism had already become part of art-history. A few years later, it was simply being seen as yet another artistic trend among many others in the first half of the 20th century, and appraised for its historical significance. Even Raoul Hausmann chose this moment to seek a new way ahead: "Dada was dead, without glory and without a state funeral. Simply dead. The DADAists returned to private life. I declared myself as Anti-DADA and a PREsentist, and took up the fight on another level together with Schwitters."

Hanover – kernel- and Husk-Dadaists

Raoul Hausmann had met Kurt Schwitters at the end of 1918 in the Café des Westens, when the latter introduced himself with the words: "I am a painter and nail my pictures." The two became friends at once. However, when Hausmann presented Schwitters' request for

23.3.1919 — The erstwhile Socialist politician Benito Mussolini forms the fascist organisation "Fasci di combattimento" in Milan
24.3.1919 — Käthe Kollwitz, Lovis Corinth and other artists are appointed to the Prussian Academy of the Arts in Berlin

20

> "Freedom: Dada, Dada, Dada,
> crying open the constricted pains,
> swallowing the contrasts and all
> the contradictions, the grotesqueries
> and the illogicalities of life."
>
> Tristan Tzara

membership of the Club Dada the next day, he was forced to accept that "we knew next to nothing of this Schwitters". But an even more decisive factor was that "Huelsenbeck didn't like him". Like many others, Kurt Schwitters was denounced by Huelsenbeck as imitative, as well as for having an allegedly immoral eye for business. "In recent times, Dadaism has been embraced by many publishers on business grounds and by many poets on the make," he warned in the "Dada Almanac", published in 1920. The surprising commercial success of Schwitters' verse collection "An Anna Blume" only seemed to confirm these fears. Supported by a skilful advertising campaign, the slim volume sold more than ten thousand copies within a few months. In terms which could not be misunderstood, Richard Huelsenbeck therefore noted: "Dada vigorously and categorically rejects works such as the famous 'Anna Blume' by Mister Kurt Schwitters." His dismissive attitude was finally confirmed, however, by a visit to Schwitters in Hanover: "He lived like a Victorian petit bourgeois – we called him the abstract Spitzweg, the Caspar David Friedrich of the Dadaist revolution," Huelsenbeck later recalled, and added aghast: "I have never been able to come to terms with the similarity of Schwitters' bourgeois and revolutionary worlds."

Schwitters himself reacted to his rejection by the Berlin Dadaists in general and to Huelsenbeck's attacks in particular with a self-assured polemic of his own. In a magazine article in December 1920, he counter-attacked, wickedly distinguishing between what he called the kernel-Dadaists and the husk-Dadaists. This was a play on Huelsenbeck's name, "Huelse" being the German for "husk". "In the beginning there were only kernel-Dadaists," declared Schwitters in the article. "The husk-Dadaists peeled off from this original kernel under their leader Huelsenbeck, taking parts of the kernel with them." And Schwitters added, in a burlesque of Huelsenbeck's formulation in the "Dada Almanac": "Merz vigorously and categorically rejects the illogical and dilettante views of art held by Mister Huelsenbeck." At the same time, Schwitters proclaimed his artistic and personal sympathy with some of the artists whom he called kernel-Dadaists, such as Hans Arp, Tristan Tzara and Francis Picabia. But above all, he enjoyed an intense friendship with Raoul Hausmann and Hannah Höch, with whom he frequently undertook joint activities.

As early as the summer of 1918, Kurt Schwitters had joined the circle centring on Herwarth Walden's gallery Der Sturm in Berlin. Der Sturm now provided him from now on the artistic home in the capital which the Club Dada would not. Schwitters exhibited a number of times in the Der Sturm gallery, and published regularly in the magazine of the same name. Particularly important was his first solo exhibition, which Der Sturm staged in July 1919, and in which Kurt

17.4.1919 — Charlie Chaplin, David Wark Griffith, Lillian Gish and other artists form the film company United Artists

17.5.1919 — First transatlantic flight in the enormous NC-4

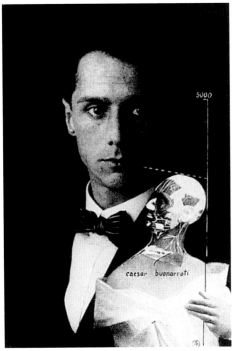

22

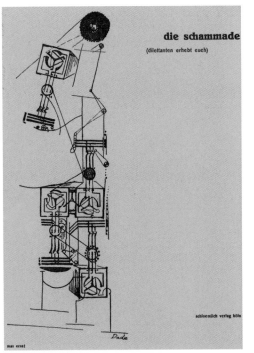

23

22. MAX ERNST
<u>The Punching Ball or Buonarotti's Immortality</u>
<u>or Max Ernst and Caesar Buonarotti</u>
1920, collage, photograph and gouache on paper,
17.6 x 11.5 cm
Private collection

23. MAX ERNST
<u>"Die Schammade"</u>
Title page of the periodical, 1920,
edited by Max Ernst and Johannes Baargeld

24. MAX ERNST AND HANS ARP
<u>Physiomythological Diluvial Picture (Fatagaga)</u>
1920, collage and mixed technique, 11.2 x 10 cm
Hanover, Sprengel Museum

25. JOHANNES THEODOR BAARGELD
<u>Typical Vertical Misrepresentation as a Depiction</u>
<u>of the Dada Baargeld</u>
1920, photomontage, 37.1 x 31 cm
Zurich, Kunsthaus Zürich

Schwitters first presented his works under the term "Merz". He had used the word "Merz" (which has no meaning in German) as a fragment in one of his first assemblages, having cut it out of the name "Kommerz- und Privatbank" (Commercial and Private Bank) and introduced it into one of his works. The assemblage was then given the title *Merz picture* on the basis of this snippet of text. Unable to use the term Dada for his art, he called all his art after this work "Merz": "Having exhibited these works for the first time at Der Sturm in Berlin, I now sought a collective name for this genre, as I was unable to classify my pictures according to old categories such as Expressionism, Cubism, Futurism or whatever. I now called all my pictures generically Merz pictures, after the characteristic picture."

For Schwitters, the Merz principle was superior to pure oil-painting if for no other reason than that it did not just use paint, but any artistic or everyday material whatever. In the process, all the materials used are subsumed into an abstract pictorial composition. He once summarized the creation of these early *Merz pictures* as follows: "At first I constructed pictures from the material which I happened to have conveniently to hand, such as tram tickets, cloakroom tickets, bits of wood, wire, string, twisted wheels, tissue paper, cans, glass splinters etc. These objects are integrated into the picture either as they are, or altered, according to the demands of the picture. By mutu-

al comparison they lose their individual character, their individual poison. They are dematerialized, and are the material of the picture." Schwitters always went out of his way to stress the aesthetic quality of his works of art, thus emphasizing once more the difference between them and the Dadaist objects: "The pure Merz is art, pure Dadaism is non-art; both deliberately." With their political anarchism and their anti-art gesture, the Berlin Dadaists must naturally have felt this, if anything conservative, view of art on Schwitters' part to be a provocation.

Schwitters' Merz art is in no way limited to collages, which he called *Merz drawings*, or to the larger-format assemblages, the so-called *Merz pictures*. The term quickly became, for him, synonymous with all his artistic activities. Thus he produced a number of *Merz sculptures* and an extensive body of *Merz poetry*. Kurt Schwitters designed models for a *Merz stage*, and several pieces of *Merz architecture*. He founded the *Merz* advertising centre, which, in contrast to the Dada Advertising Company of the Berlin Dadaists, actually took on and carried out numerous contracts, and in the late 1920s, even undertook the revamping of all the written material produced by Hanover City Council. Finally, Schwitters had the vision of all his activities being subsumed in a utopian Merz total world picture. "Merz means creating relationships, preferably between all the things in the

28.6.1919 — Signing of the Versailles Peace Treaty
18.11.1919 — US Senate refuses to ratify the Versailles Treaty and does not join the League of Nations

4.8.1919 — Opening of the Nationalgalerie's new gallery in Berlin

22

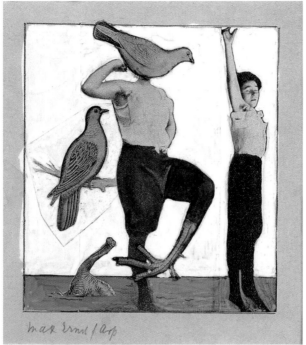

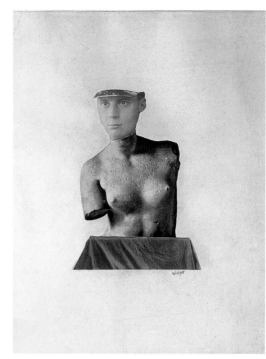

**"Dada is the sun,
Dada is the egg.
Dada is the police
of the police."**
Richard Huelsenbeck

world," he proclaimed as early as 1924 in one of his theoretical mani-festos, and three years later was able to assert: "Now I can call myself Merz."

Cologne – Dada as a burgeois art business?

Unlike Kurt Schwitters, the Cologne Dadaists were represented at the "First International Dada Fair" in Berlin. Even before it opened in June 1920, Max Ernst, known as the "Dadamax", Johannes Theodor Baargeld, whose real name was Alfred F. Gruenwald, and Hans Arp, who had arrived from Zurich at the beginning of 1919, had organized the "Dada Pre-spring" at the Winter tavern in Cologne, with works by – apart from the organizers themselves – Francis Picabia, Heinrich Hoerle and Louise Straus-Ernst. Some of the exhibits which survived the aggression of the public were subsequently sent to the "Dada Fair" in Berlin.

Cologne was not the centre of a broad Dada movement. The group's activities were focused primarily on the trio of Ernst, Baargeld and Arp. They not only organized the "Dada Pre-spring", but published such magazines as "Die Schammade" and "Der Ventilator", the latter having a print-run of 40 000 copies. "Die Schammade" was subtitled

"Dilettantes arise" and on its cover page presented an absurd, Dadaist machine construction by Max Ernst. Although it never got past its first number of February 1920, "Die Schammade" was of decisive impor-tance for the Cologne Dadaists. Via the international authors who had been invited to contribute, they were able to make numerous contacts in the Dadaist centres of Zurich and Berlin. For Max Ernst, the maga-zine also marked the interface between his activities as a Dadaist in Cologne and his approach to French Surrealism, whose future spokesman André Breton, along with Louis Aragon, Paul Eluard and Tristan Tzara sent detailed articles to "Die Schammade". For Hans Arp, Cologne was no more than a brief stop-over on his way to Paris. In 1922 he was eventually followed there by Max Ernst.

As early as March 1919 Max Ernst, together with his wife Louise Straus-Ernst and the artist Willy Fick had taken part in a dis-ruptive Dada action on the occasion of the premiere of the play "Der junge König" (The Young King) by Raoul Konen in Cologne's playhouse. Heckling loudly ("Throw the author out, this is not watch-able!") they interrupted the performance until the police came to take them away. They saw their protest both in political and artistic terms, as they were as opposed to established Expressionism as they were to political conservatism. "For us in Cologne in 1919, Dada was pri-marily a mental attitude. We set out to prevent the performances of

1920 — Introduction of women's suffrage in the USA
Doctor Caligari" by Robert Wiene

27.2.1920 — Premiere of the Expressionist film "The Cabinet of
13.3.1920 — Kapp-Putsch in Berlin against the Weimar Republic

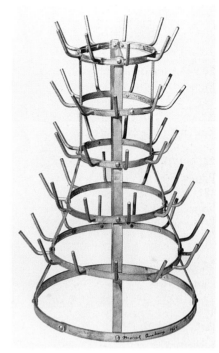

"It's not Dada that is non-sense – but the essence of our age that is nonsense."

The Dadaists

the 'Young King', a monarchist and patriotic play of provocative stupidity," was how Ernst described their motives. But just six months later, with the founding and first exhibition of Gruppe D, the Dadaist movement in Cologne also got some organizational structure. So many artists were involved in the exhibition, however, among them Heinrich Hoerle, Otto Freundlich and Paul Klee, that others, such as Franz Wilhelm Seiwert, withdrew their participation on the grounds that Dada had become a bourgeois art business. Although this judgement seems too harsh, the only event in Cologne to uphold the anti-art impulse of Dadaism was the event in the Winter tavern. Opened in April 1920, the "Dada Pre-spring" was closed by the police after just a few days on the grounds that it was disseminating pornography. The only piece of evidence, however, was the reproduction of a classical nude by Albrecht Dürer which Max Ernst had incorporated into one of his collages. The organizers Ernst and Baargeld celebrated the official re-opening as a personal triumph. "DADA conquers" they printed in large letters on the new exhibition poster, and ironically emphasized their pro-state attitude: "DADA stands for law and orders!" (using the German word "Orden", which means "orders of chivalry, medals", in place of the usual "Ordnung"). In his autobiography Max Ernst listed the historical high points of this exhibition individually: "Baargeld's 'Antropophiler Bandwurm' and 'Fluidoskeptrik der Rotswita von Gandersheim', Dadamax's 'Unerhörte Drohung aus den Lüften' and 'Original-Laufrelief aus der Lunge eines 17jährigen Rauchers'. The works destroyed by the public in fits of rage were regularly replaced by new ones." According to other sources, the organizers explicitly urged visitors to smash a sculpture by Max Ernst with a hammer they made available for the purpose.

Within such prescribed limits, Max Ernst too accepted the anti-art attitude of Dadaism. Otherwise he proved to be a brilliant creator of pictures who, like no other artist, knew how to exploit all the possibilities of collage, and in the decades to come, how to try out a succession of new pictorial techniques. "What is collage?" he asked in his "Biographical Notes", and answered in the third person: "Max Ernst for example has defined it thus: the collage technique is the systematic exploitation of the chance or artificially provoked confrontation of two or more mutually alien realities on an obviously inappropriate level – and the poetic spark which jumps across when these realities approach each other." Max Ernst's description of the collage principle is indeed closer to the Surrealist approach to picture creation than to the ironic or aggressively political montages of the Berlin Dadaists. The true spirit of Dada emanates above all from his collage drawings of sense-less mechanical constructions and biological structures.

--

Juli 1920 — Max Liebermann becomes president of the Prussian Academy of Arts

8.8.1920 — Adolf Hitler announces his 25-point programme in the Hofbräuhaus Munich

--

26. MARCEL DUCHAMP AND MAN RAY
<u>Monte Carlo Bond</u>
1924, original design, collage on coloured litho,
additions in black ink, 29.5 x 19.5 cm
Zurich, Kunsthaus Zürich

27. MARCEL DUCHAMP
<u>Bottle Rack</u>
1914, ready-made, galvanised iron,
height 64 cm, Ø 42 cm
Paris, Musée National d'Art Moderne,
Centre Pompidou

28. FRANCIS PICABIA
<u>Cacodylic Eye</u>
1921, oil and collage on canvas,
148.6 x 117.4 cm
Paris, Musée National d'Art Moderne,
Centre Pompidou

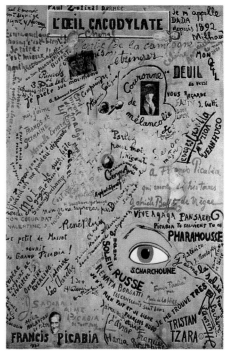

28

New York – "Dada is American"

In New York it was likewise chiefly the émigré European artists who brought the anarchic Dada impulse to the city. The two Frenchmen Marcel Duchamp and Francis Picabia met here in 1919 and got together with Man Ray from Philadelphia, the gallery-owner and photographer Alfred Stieglitz, and the poet and patron of the arts Walter Arensberg. Cheaply produced magazines were, for the New York Dadaists too, an important means of communication with the other international centres of the movement. In 1915, Stieglitz had started publishing the series "291", whose title was derived from the address of his gallery. Two years later it was superseded by Picabia's "391", which appeared until the end of 1924. Whatever the title might otherwise suggest, in his pamphlet "Dada is American" Walter Arensberg emphasized above all the international character of the movement: "Dada is American, Dada is Russian, Dada is Spanish, Dada is Swiss, Dada is German, Dada is French…" And he closed with a typical Dada contradiction: "I, Walter Conrad Arensberg, American poet, declare that I am against Dada, because it is only thus that I can be for Dada."

New York also had its share of typical Dada scandals. Thus at a performance organized by Marcel Duchamp, the boxer and man of let-ters Arthur Cravan shocked the respectable citizenry by presenting them with a suitcase full of dirty underwear. In contrast to their counterparts in Berlin, however, the New York Dadaists were not interested in anarcho-political spectacle for their own sake. The city on the other side of the Atlantic was too far from the battlefields of Europe for their horrors to need to be discharged in provocative, oppositional and anti-rationalist gestures.

In contrast to Zurich or Paris, here it was not the literary members who claimed to be the spokesmen of the Dadaist movement. Rather, in the persons of Picabia, Man Ray and Duchamp, it was the visual artists who made the most important contributions to New York Dada, introducing developments that paved the way for much of subsequent 20th-century art. At the same time, their works too came under the heading of "anti-art". Francis Picabia drew absurd mechanical constructions which parodied the prevailing enthusiasm for technology and the modern faith in progress. Man Ray used everyday utilitarian objects and pictorial motifs which he alienated by combining them with other materials and less-than-obvious titles.

For Marcel Duchamp's ready-mades, not even the Dadaist idea of anti-art is adequate. When in 1917 he presented a signed urinal under the title *Fountain* to the jury-less exhibition of the New York Society of Independent Artists, his intention went beyond a mere salu-

11.8.1920 — First Ecumenical Conference (World Council of Churches) is held in Geneva, with church representatives from Europe, America and the Orient. The Roman Catholic Church fails to participate **29.10.1920 — Premiere of the film "The Golem" by Paul Wegener**

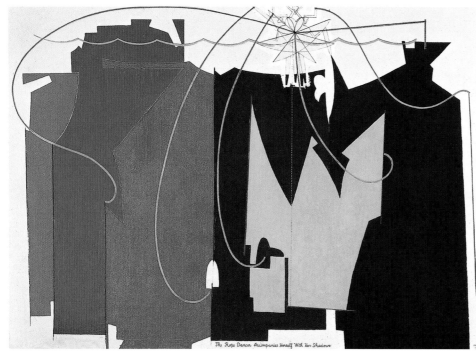

The Rose Dancer Accompanies Herself With Her Shadow

29

> "What is generally
> termed reality is,
> to be precise,
> a frothy nothing."
>
> Hugo Ball

tary provocation of the academic art business. Ready-mades are selected utilitarian objects which are raised to the status of works of art simply by dint of being defined as such by the artist and being put on display in an exhibition. Duchamp was not concerned with the Dadaist rejection and destruction of the existing concepts of art, but with removing boundaries and taking this process to its logical conclusion. His ready-mades stand above all for a radical redefinition of what can constitute a work of art, how we can perceive it, and how we deal with it. For the first time, the ready-mades drew the attention of the beholder to the importance of the context for the definition and evaluation of a work of art. This redefinition, and the so-called "context debate" which it initiated made Marcel Duchamp the most influential artist of the 20th century.

Paris – "It is our differences which unite us"

The international Dada movement was born in Zurich in 1916 and buried just six years later in Paris. But it was in the French capital that it experienced a final and belated heyday. During the war, the young generation of artists had either served at the front, or else fled abroad in time to avoid military service. Only after the Armistice of 11 November 1918 did Louis Aragon, André Breton, Philippe Soupault and Tristan Tzara gradually return to Paris. In 1919, Francis Picabia and Marcel Duchamp returned from New York. Their colleague from there, Man Ray, followed two years later. After a stop-off in Cologne, Hans Arp arrived in 1920 in Paris, where he was visited that same year by Max Ernst, who himself moved to the French capital in 1922. Major impetus was given to the Dadaist movement by the arrival of Tristan Tzara in January 1920. Breton had urged him several times to come back from Zurich, writing for example at the end of 1919: "You'll be coming at just the right moment. Life here has become more active." Just six days after his arrival, Tristan Tzara proclaimed the birth of Parisian Dadaism at the first Friday soirée of the magazine "Littérature". Tzara enjoyed his role of revolutionary spokesman, and here in Paris he could speak with the authority which derived from the aura associated with being one of the founding fathers of the movement in Zurich. The other leading figure in the French group was the likewise 24-year-old poet André Breton.

In Paris too, Dada was first and foremost a literary movement, but in contrast to the Cabaret Voltaire in Zurich, where the Dadaists performed a lively programme of short recitations, poems, musical numbers and dances, their French counterparts expressed themselves chiefly through their numerous publications. It seemed almost

4.5.1921 — The London Conference sets the reparations payments to be made by Germany at 13.2 million gold mark
27.7.1921 — Adolf Hitler becomes Chairman of the NSDAP **25.8.1921 — Peace Treaty between USA and Germany**

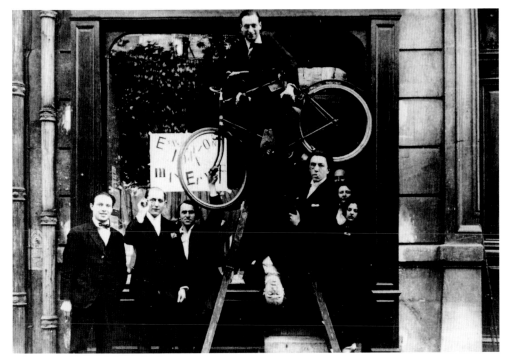

29. MAN RAY
<u>The Rope Dancer Accompanies Herself</u>
<u>with Her Shadows</u>
1916, oil on canvas, 132.1 x 186.4 cm
New York, The Museum of Modern Art,
Gift of David Thompson

30.
<u>"Dada Max Ernst"</u>
Opening of the exhibition at Galerie Au Sans Pareil,
Paris, 2 May 1921
Paris, Musée National d'Art Moderne,
Centre Pompidou
From left to right: René Hilsum, Benjamin Péret,
Serge Charchoune, Philippe Soupault, Jacques Rigaut
(with his head lowered), André Breton

30

as if each of the Paris Dadaists had founded his own mouthpiece, in which to publish his own manifestos, essays and poems and those of his friends. Arthur Cravan's magazine "Maintenant", which appeared from 1912 to 1915, became the role model for many of the later publications. In 1919, Breton founded the magazine "Littérature", while Francis Picabia continued to publish his own "391". Tzara published the series "Dada", and the Belgian Paul Dermée added to this flood of magazines at the end of 1920 with his "L'Esprit Nouveau". Paul Eluard called his publication "Proverbe". One rendezvous for the French Dadaists was the Au Sans Pareil bookshop and gallery, founded in 1919, which staged Max Ernst's first Paris exhibition in May 1921.

André Breton found a metaphor for the Paris group which encapsulated the typical Dadaist oxymoron: "It is above all our differences which unite us," he observed. Thus it is hardly surprising that his alliance with Tristan Tzara, whose arrival on the scene he had awaited with such yearning, broke up again as early as 1921. As the Paris Dadaists had only come together after the war had ended, they lacked any common aim on which to concentrate their rage and their actions.

André Breton had discovered the technique of automatic writing as early as 1920. The following year he went to Vienna to see Sigmund Freud, who had founded a theory of the interpretation of dreams linking them to the subconscious. Breton went on to replace the aggressive, provocative and satirical contributions of Dadaism with a literature which excluded any rational control of the creative process by employing techniques of automatism and chance, and drawing on the subconscious. In 1924 he published his new insights in the "First Surrealist Manifesto", in which he demanded "a 'think-diktat' free of any control by reason, beyond all considerations of ethics and aesthetics." Breton's methodology filled a vacuum which for many artists and writers had arisen now that, following the end of the war, Dadaism was increasingly losing its influence and raison d'être. Enthusiastically, Paul Eluard, Philippe Soupault, Francis Picabia, Hans Arp, Man Ray and Max Ernst joined with him to form the Paris Surrealist group. Even Tristan Tzara, after initial doubts, took an active part in the movement after 1929.

In the decades to come, Dadaism was revived time and again, above all as a mental attitude. The Dadaist sound-poems inspired the Concrete Poets of the 1960s, and the French Nouveaux Réalistes even called themselves Neo-Dadaists to start with. But while artists like Arman, Raymond Hains and Jean Tinguely shouted their appreciation of Dadaism from the rooftops, the survivors of the original movement were less impressed by their young admirers. "How dare these people – artists, or whatever you want to call them – how dare they call themselves Dadaists?" asked an angry Richard Huelsenbeck in 1961.

3.4.1922 — Joseph Stalin becomes General Secretary of the Communist Party of Russia
15.8.1922 — The German Government announces it is insolvent **30.12.1922 — Founding of the USSR**

HANS ARP

Relief Dada

1916, wood, painted, 24 x 18.5 cm
Basle, Öffentliche Kunstsammlung Basel, Kunstmuseum,
Schenkung Marguerite Arp-Hagenbach

b. 1887 in Strasbourg, d. 1966 in Basle

Like many of his fellow Dadaists, Hans Arp was an acknowledged talent in both literature and the visual arts. His first poem was published as early as 1903, while his academic training as an artist had led him between 1901 and 1907 from Strasbourg, the capital of Alsace, which at that time belonged to Germany, to Weimar and then to Paris, where he attended the renowned Académie Julian, at which Marcel Duchamp also took painting lessons in 1904. Arp was caught out in Paris by the outbreak of the Great War. Classified as an enemy alien, he managed to take refuge in Switzerland in 1915.

The *Relief Dada* dates from 1916, the year the movement was founded in Zurich. The object is part of a series named *Earthly Forms*. Following a group of works he had executed jointly with his lover Sophie Taeuber, which consist of austerely geometric additions of forms, what we have here is a surprising new beginning within his visual œuvre. The *Earthly Forms* are reliefs in wood which Hans Arp has screwed together one on top of the other, and then painted. Compared with earlier works, their vocabulary of organic and biomorphic forms is conspicuous. In these constructions, he banned the right angle from his repertoire, and gave the individual pieces of wood curved, wave-like outlines.

Another noteworthy feature is that the elements are not fastened to a neutral rear wall. Instead, their external contours grope irregularly into the surrounding space. For art, this was a new experience and an important formal insight. By dispensing with a frame or a base, the gulf between the beholder's actual space and the artwork's own space was abolished. In respect of fitting and painting, too, Hans Arp has attempted to avoid any illusionism. Not only does the material structure of the wood retain its visible identity in spite of the coat of paint, but the surface also still shows traces of the brush-strokes and casual craftsmanship. Arp explicitly reveals the five screws which hold the individual parts of *Relief Dada* together. The aesthetic issues which concern Hans Arp here already confirm that he was keeping a certain distance from the anti-art assertions of the other Zurich Dadaists.

The term *Earthly Forms* hints at Arp's confrontation with nature, whose formal language provides the exemplar for his own artistic creativity. The poetic titles of some of the reliefs in this series, such as the 1916/17 *Interment of the Birds and the Butterflies*, or *Plant Hammer*, dating from 1917, along with their abbreviated forms, still hint at the landscapes which provided their inspiration. In the case of *Relief Dada*, there is no longer any sign of a figurative representation of nature. The work's formal vocabulary is abstract, but is still oriented towards organic structures. The contours are surprising, irregular and slightly curved. They follow no pre-formulated principle. In the wood reliefs, the individual coloured elements come together to form a "harmony in parallel with nature", as the Impressionist Paul Cézanne described his own painting. Arp's other artistic relationships were with the Blauer Reiter painters Wassily Kandinsky and Franz Marc. As the latter had already done with his animal motifs, in the midst of war Arp sought in nature a peaceful and ethical counter-image to the dehumanized killing on Europe's battlefields. To this extent, Arp's attitude was in accord with that of his fellow-Dadaists in Zurich and Berlin, even though he found a quite different pictorial language to express his revulsion.

"We do not wish to imitate nature, we do not wish to reproduce. We want to produce. We want to produce the way a plant produces its fruit, not depict. We want to produce directly, not indirectly. Since there is not a trace of abstraction in this art we call it concrete art."

Hans Arp

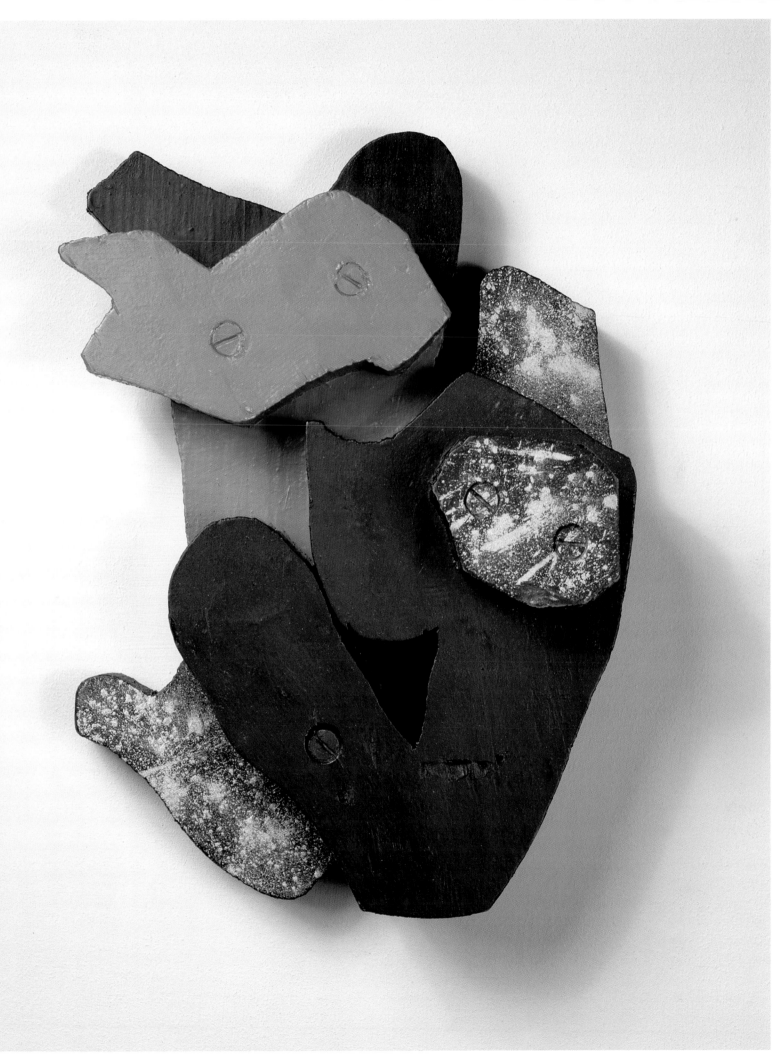

Collage Arranged According to the Laws of Chance

c. 1917, collage, 48.6 x 34.6 cm
New York, The Museum of Modern Art, Purchase. 457.1937

Two features were of decisive importance for Hans Arp's Dadaist work: co-operation with other artists, and the principle of chance. Both served to enable him to subvert the myth of the individual artistic genius. Instead, he sought to give his works an impersonal character. For his reliefs, he usually sketched out the shapes of the wood elements before having them cut out by a joiner. Like this, he could make multiple copies of the individual motifs, or create different variations for different works. In his collages, a random structure often forms the starting situation for his artistic design. 1917 or thereabouts saw the appearance of a whole collection of such collages, which he entitled *Arranged According to the Laws of Chance (Nach den Gesetzen des Zufalls geordnet)*. This claim notwithstanding, it takes no more than a cursory glance at the work illustrated here to see that the arrangement of the papers is by no means so random as the title would have us believe. In his memoirs "Dada Profile", the Zurich fellow-Dadaist and future chronicler of the Dadaist movement, Hans Richter, commented as follows on Arp's use of the random element: "A torn corner became the starting-point for new compositions, a chance rain-blot the centre of an explosion, which then spread across further areas of the picture. The recognition of chance as the actual centre of Dada vitalized him and became in his hands the magic which imbued not only his work but his whole existence."

The chance principle however is only ever the basis of the design. Hans Arp cut the twelve coloured papers for the collage into approximate squares, albeit invariably avoiding actual right angles. These snippets of paper were then allowed to fall on to the cardboard. The resulting configuration served to inspire the next "ordering" intervention. As is known, Tristan Tzara also suggested the same technique for creating Dadaist poetry. Arp pushed his bits of paper around on the cardboard until he had found a definitive composition. In the example illustrated here, the dark papers group in dance-like fashion around a pale quadrilateral in the centre. The paper surfaces do not overlap, but merely touch at their vertices. Two pieces of paper extend beyond the edge of the cardboard, or rather would have, had not Arp cut them off at this point. The final result evinces a balance between compositional order and the principle of chance. The chance configurations, which are manifested in the details, are so to speak cancelled out in the total composition. Thus the motif is in a constant state of tension. The shaping hand of the artist is apparent to the beholder, but at the same time there is no dominant order.

The technique used here by Hans Arp, namely to allow his picture construction to be guided by chance structures, was also being used at the same time by Max Ernst. But it was above all the Surrealists, who, in the 1920s, were to make random and uncontrollable techniques the principles of their artistic and literary creativity. Hans Arp never allowed himself to be totally absorbed into the Dadaist movement, always maintaining a critical aloofness. This was also true of his later co-operation with the Paris Surrealists and of his membership of the international art association Abstraction-Création. Surprisingly, his independent work allowed links with all these very different artistic movements.

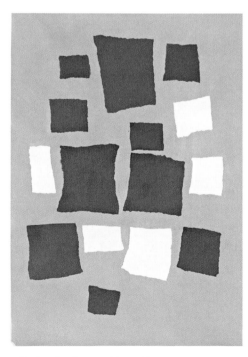

Rectangles Arranged According to the Laws of Chance, 1916/17

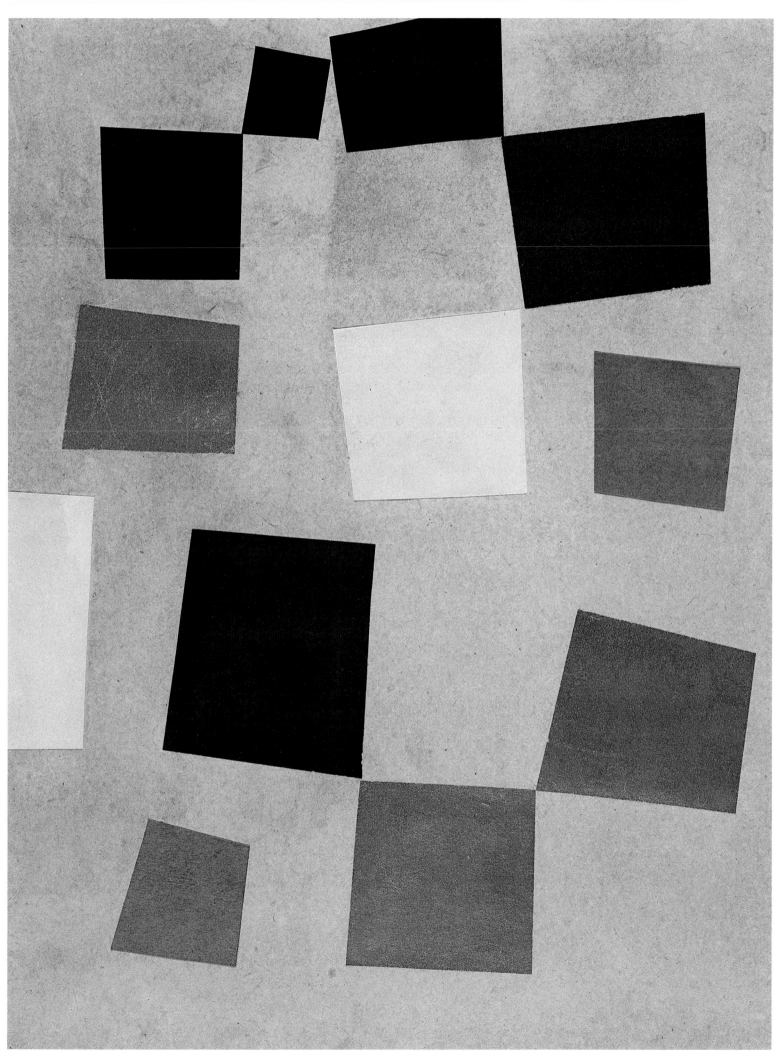

i-picture

c. 1920, collage, 20.6 x 16.6 cm,
Zurich, Kunsthaus Zürich

Hans Arp first met Hugo Ball as early as 1915 at the Hack bookshop in Zurich. When Ball opened his Cabaret Voltaire in February 1916, Arp was responsible for the decor. He chose the colours for the walls and used them to exhibit works by himself and by other artist friends. Later Hans Arp took part in the cabaret programme by reading his own poems. Nevertheless, he kept aloof from certain Dadaist actions, and in a letter to a girl-friend complained about the anti-German attitudes of his fellow-artists. After the end of the movement in Zurich, Hans Arp stayed for a time in Cologne, where he created collages together with Max Ernst, for which they invented the term "Fatagaga" pictures. The word was an acronym based on fabrication de tableaux garantis gazométriques (production of guaranteed gasometric pictures). Arp was always particularly interested in co-operation with other artists. This was because, like the principle of chance, it allowed him to hive off a part of the creative process. He also produced many works in collaboration with Sophie Taeuber, his future wife, whom he had met in November 1915 at an exhibition at the Galerie Tanner in Zurich. The repertoire of austere geometric forms in the *i-picture* illustrated here (dating from c. 1920) is ultimately due to her influence. As an artist and above all as a designer, Sophie Taeuber preferred a vocabulary of reduced, geometric and blocklike forms.

This small-format collage is composed of various pieces of paper cut into rectangular shapes. Their austere arrangement alone (the elements are all positioned parallel to the sides of the picture) distinguishes the work from the earlier (c. 1917) *Collage Arranged According to the Laws of Chance*. The base at the bottom of the picture occupies some two-thirds of the total height, and is dominated by a solid dark area. This is balanced at the top by a second rectangle cut from the same piece of paper.

The most striking detail of the work is, however, the powerful representation of the letter "i". Arp did not cut it out of a printed text and stick it into the composition, but drew it using a stencil. Fragments of text do occasionally crop up as graphic design elements in other collages by this artist, but here the motif could go back to two other sources. Time and again, Hans Arp invented figurative "abbreviations" which can be seen as either iconic in character or as abstract shapes.

In this sense, it would be possible to recognize in the letter the abstract representation of a human figure with a stylized head and body.

The letter "i" also plays an important role in the work of Kurt Schwitters. From 1920, he gave the name *i-drawings* to those of his collages which were created not through the composition of individual elements, but by defining a detail of a larger motif. Hans Arp, who at this time had been friends with Schwitters for two years, could have appropriated this method for the work illustrated here, having cut the composition out of a larger collage. The final addition of the letter "i" might then serve as a somewhat unsubtle clue to the way the work was created.

Hans Arp always accorded his work an ethical component. As early as 1915, on the occasion of his exhibition at the Galerie Tanner, he introduced his works in the catalogue with the words: "These works are buildings constructed of lines, surfaces, shapes, colours. They seek to approach what is inexpressible about man and eternity. They represent a turning away from the self-seeking aspect of mankind."

"I allowed the old fortresses of art be besieged by dreams. Dreams are mightier than atom bombs, what are the flights of supersonic aircraft compared to the flights of saints, dreamers and poets?"

Hans Arp

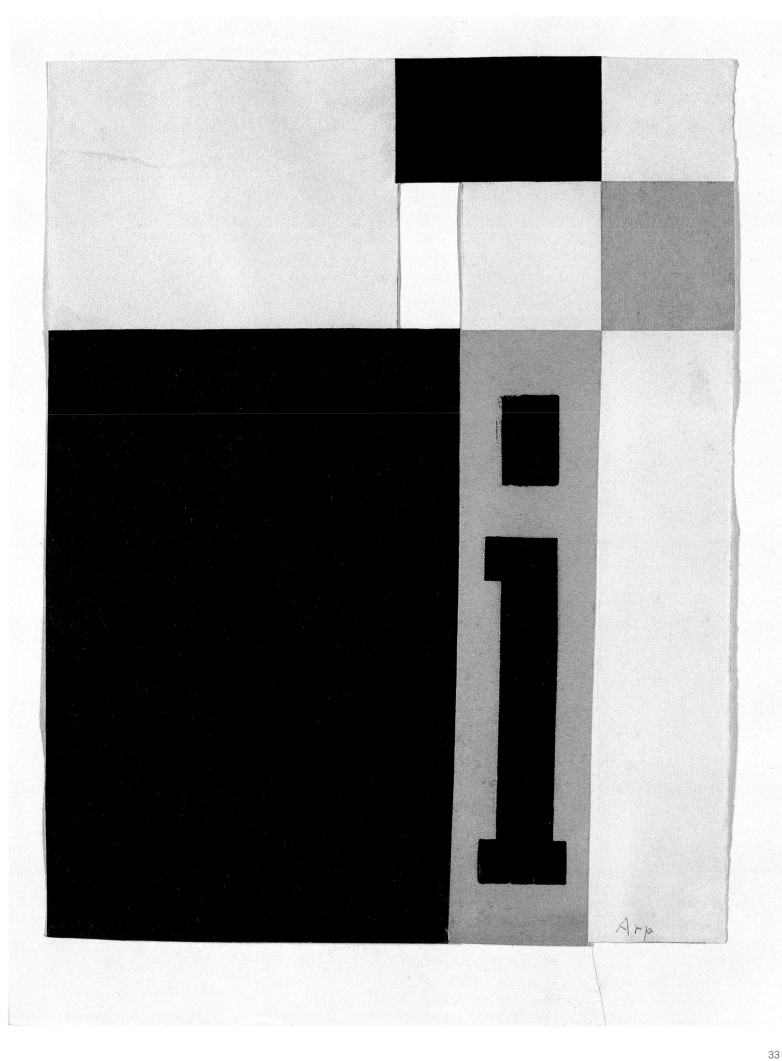

RAOUL HAUSMANN

Tatlin Lives at Home

1920, collage and gouache, 40.9 x 27.9 cm
Stockholm, Moderna Museet

**"Dada ... wants over and
over again movement:
it sees peace only in dynamism."**
Raoul Hausmann

b. 1886 in Vienna, d. 1971 in Limoges

Raoul Hausmann was fourteen years old in 1900 when he moved with his family from Vienna to Berlin. Taking instruction from his father, an artist, it was here that he made his first attempts at painting. Stylistically, Hausmann took his bearings at first from Expressionism and Futurism. As early as 1905 he is said to have made the acquaintance in Berlin of the older Johannes Baader. Later he made friends with Erich Heckel and joined the circle which centred on Herwarth Walden's gallery Der Sturm. Before the outbreak of the First World War, he had already written a number of art reviews for its magazine of the same name. His friendship with the writer Franz Jung and his meeting with the Zurich Dadaists Richard Huelsenbeck and Hans Arp made Hausmann one of the leading figures in the Dadaist movement in Berlin. His visiting-card in 1919 identified him grandiloquently as the "President of the Sun, the Moon, and the little Earth (inner surface), Dadasopher, Dadaraoul, Ringmaster of the Dada Circus". His title of "Dadasopher" was bestowed by fellow-members of the Dada group in Berlin.

As with the name "Dada" itself, whose parentage was claimed by, among others, Hugo Ball, Richard Huelsenbeck and Tristan Tzara, the paternity of the photomontage technique was also disputed. Raoul Hausmann claimed to have discovered it in 1918 while on holiday on the Baltic with Hannah Höch. In a photographer's shop-window they chanced upon pictures in which the faces of the persons photographed had been replaced by different heads.

The photomontage technique was characteristic of Berlin Dada, where it was a further development of Cubist collage, from which it differed primarily by the use of printed text elements and photographic images. The use of the term "montage" was chosen deliberately in order to deprive these works of any "artistic" character. After all, there was no way the Berlin Dadaists wanted to be seen as artists in the traditional sense. By describing themselves as photomonteurs (photofitters) instead, they took up a position in the, to them, far more congenial vicinity of the proletarian industrial workers and fitters.

The photomontage *Tatlin Lives at Home (Tatlin lebt zu Hause)* dates from 1920. For years the work, like Hausmann's other important montage *Dada Conquers*, was thought to be lost. The two pictures hung side by side at the "First International Dada Fair", held in Dr Otto Burchard's art gallery in Berlin, and can be made out in the background of a photograph showing Raoul Hausmann and Hannah Höch at the exhibition. Another photograph taken at the exhibition shows George Grosz and Richard Huelsenbeck holding up a sign with the words "Art is dead. Long live TATLIN'S new machine art". Hausmann's photomontage *Tatlin Lives at Home* takes up the theme of this exhortation, by presenting a portrait of the Russian Constructivist and having a complicated mechanism of pistons, wheels, gauges, gears and screws growing out of the crown of his skull. Behind Tatlin's head, the beholder can see a wooden stand supporting a kind of vessel in which there is an organic structure. The numeric inscriptions point to a biology textbook as source. The organic and mechanical worlds are the two opposite poles in Hausmann's photomontage.

According to the title, the subject of the picture is Tatlin's home. And indeed, Hausmann has assembled his pictorial fragments in such a way that the result is a closed room with floorboards. On the left-hand wall there hangs a map. In the background to the right our gaze falls upon the hull of a ship with its propeller. The motifs suggest that Tatlin has put his brain on the stand and exchanged it for a piece of machinery. Thus the picture illustrates a Dadaist utopia in which emotional thought is replaced by mechanical thought. Only thus, according to the Dadaists, could a new (machine) art appear, which would stand up for a mechanical, rational and ultimately peaceful world.

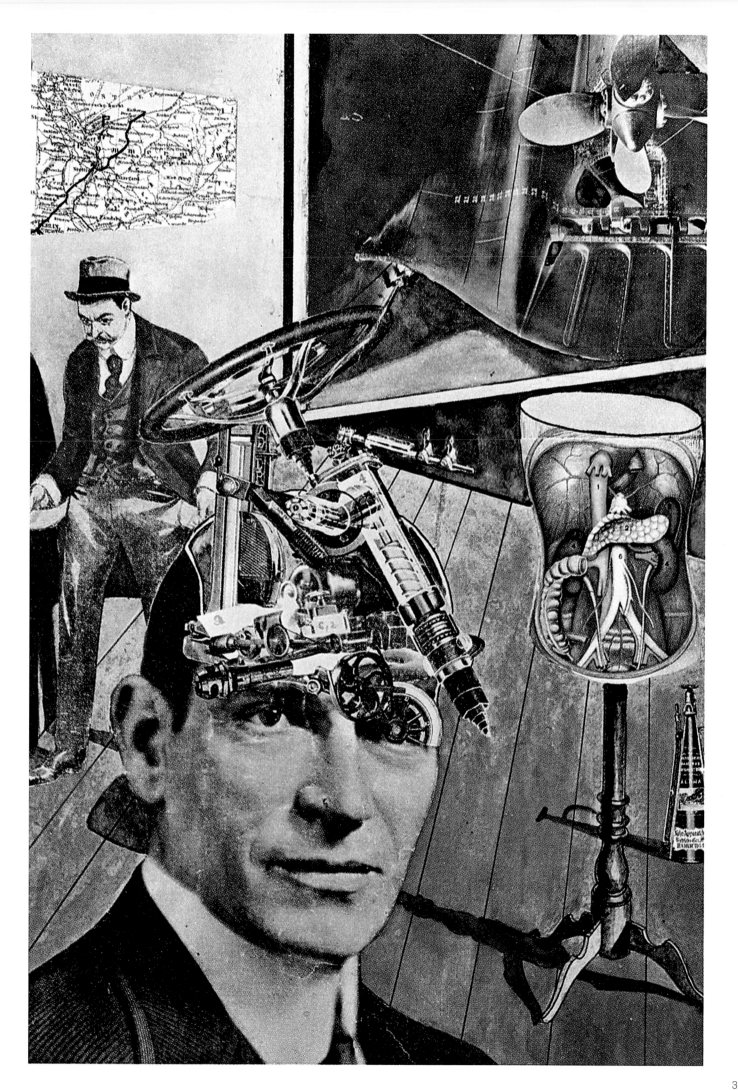

RAOUL HAUSMANN

The Art Critic

1919/20, collage, 31.4 x 25.1 cm
London, Tate Modern

In 1918 Raoul Hausmann published his manifesto, the "Synthetic Cino of Painting", in which he attacked Expressionism and proposed the use of new materials in art. Dadaism, according to Hausmann, transcended the state-of-the-emotions art of the Expressionists and their "exploitation of so-called echoes of the soul" in painting. Dada, he said, was using an un-hackneyed pictorial vocabulary to provide new artistic impulses, and, he claimed, created a radical reality of expression by its use of fragments of the real world. "The painter paints as the ox bellows: this solemn insolence of bogged-down impostors, with an infusion of profundity, has provided happy hunting-grounds for German art-historians in particular. A child's discarded doll or a brightly coloured rag are more necessary expressions than those of some ass who seeks to immortalize himself in oils in finite parlours." Thus did Hausmann give free rein to his rage against established Expressionist painting and the art-critics who were promoting it. About a year later, he took up this theme once more in his photomontage *The Art Critic ("Der Kunstreporter" [Kunstkritiker])*, which dates from 1919/20. The Expressionist artists had at this time achieved further public recognition when in 1919 the director of the Nationalgalerie in Berlin, Ludwig Justi, reserved an exhibition room just for them in the Kronprinzenpalais.

In his collage *The Art Critic*, Raoul Hausmann has created the "sitter" from a number of pictorial sources and given the reporter the face of his fellow-Dadaist George Grosz. He has stamped the bust of the figure in duplicate with the words "Constructed Portrait George Grosz / 1920", but this text has been crossed out. For what Hausmann shows here is not a portrait. Grosz merely appears in the role of the art reporter. In addition, the fact that his eyes and mouth are covered over makes him hard to identify. The two Dadaists had met in the spring of 1917. Hausmann spontaneously related his first impressions of George Grosz to Hannah Höch as follows: "This is someone who does not wear his heart on his tongue, fabulously ironic, he seems to be just chattering, but makes revealing fools of others. He is calm, confident and knows when to keep quiet. We'll be hearing more of him."

The picture is dominated by the three-quarter-length portrait of the "art reporter", which occupies a central position. He is dressed in an elegant three-piece suit and in his right hand holds an excessively large pencil, which he wields like a sword. His eyes are stuck over with pieces of paper, on which are drawn two casually sketched eyes. As a result, his vision comes across as impaired: the "art reporter" can no longer properly perceive art, the object of his criticism. His judgement is therefore correspondingly impaired. His mouth too is stuck over and replaced with teeth drawn in by Hausmann with a coloured pencil, and a collage tongue. At the back of the figure's head a banknote can be discerned: it has been cut to a sharp point. Someone seems to have shoved it down his collar: as a bribe, perhaps?

The utterances of the art critic are not comprehensible. Like two huge banners they run across the background of the picture. Only individual letters and syllables, devoid of any meaning, can be deciphered. Raoul Hausmann has stuck his portrait of the "art reporter" over one of his phonetic poster-poems. The young woman on the right-hand edge of the picture presents the object of his criticism on a board, on which a schematic male figure in a hat can be made out. As the heading, an extract from Hausmann's visiting-card, suggests, female beauty here stands for the "President of the Sun" and Dadasopher, Raoul Hausmann himself. And even the shadowy figure on the board can be identified. Hausmann has cut its outline from the business section of a daily newspaper, for we can recognize a number of relevant words such as "banks", "liquidation", "discount" and "shareholders". Above all, though, the beholder can read the word-fragment "merz", printed clearly in bold type, cut out from the word "Kommerz" (commerce). This is a clear allusion to his friend, the "Merz" artist from Hanover Kurt Schwitters, whom he is here portraying as the victim of uncomprehending and arrogant art critics. Schwitters himself had reacted to the insulting attacks of his critics with polemics of his own, the so-called "Tran-texts".

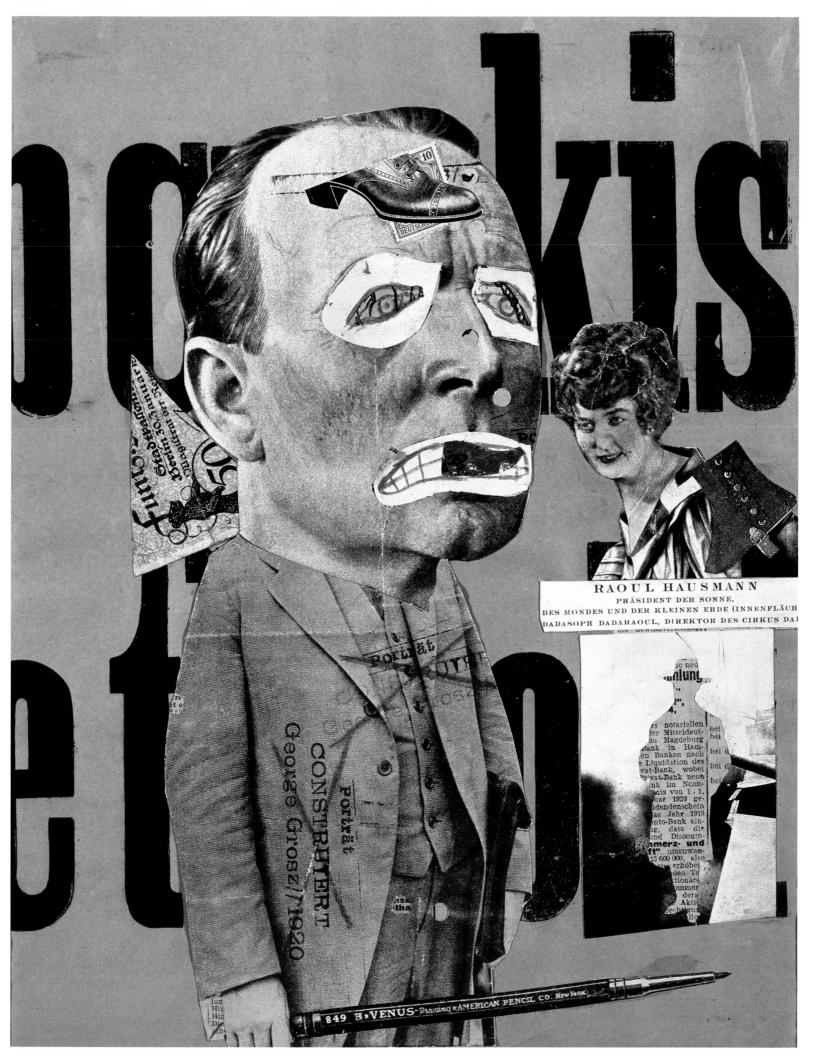

RAOUL HAUSMANN

Mechanical Head
(The Spirit of Our Age)

c. 1920, assemblage, 32.5 x 21 x 20 cm
Paris, Musée National d'Art Moderne, Centre Pompidou

In the many-faceted Dadaist œuvre of Raoul Hausmann, the *Mechanical Head (The Spirit of Our Age)/Mechanischer Kopf (Der Geist unserer Zeit)* occupies a central position. This unique assemblage was created around 1920, though Hausmann had already formulated the theoretical basis of the work two years earlier, when in his "Synthetic Cino of Painting" he demanded: "Dada: this is the perfect, valid malice, alongside exact photography the only justified pictorial form of information and balance in common experience. Anyone who takes his own most personal tendency to the point of release is a Dadaist. In Dada you will recognize your own personal state: wonderful configurations in real material, wire, glass, cardboard, cloth, organic in accordance with your own altogether perfect fragility, your battered state."

With sentences like this, Raoul Hausmann compared Dadaist art-works to photography. He wanted to transfer the latter's characteristics, its unemotional, precise and objective documentation of reality, to his own works, by using materials taken from the immediate surroundings of human beings. As a result, he hoped that the Dadaist works would be superior, in their authenticity and reality, to Expressionist painting in oil on canvas. For the same reason, Hausmann likewise used photographic elements in his collages.

Accordingly, the *Mechanical Head* is an assemblage of real *objets trouvés.* First of all we have the wooden head of a dummy that would normally be used by a hairdresser to display wigs. It has been alienated by Hausmann by having various materials attached to it. In the middle of its forehead is a tape-measure. Balanced on its crown is a telescopic beaker of the sort issued to German soldiers at the front. Also on the forehead is a sign with the number 22 printed on it. Next to this, fastened to the right temple, is the mechanical movement of a clock. As a substitute for an ear, Hausmann has attached to the head a jewellery box containing a printing roller. On the other side are a wooden ruler and a number of screws, which originally belonged to a camera. Finally, at the back of the head, the artist has nailed an old, worn-out leather purse.

In a text written many years later, in April 1966, Raoul Hausmann recalled the motivation behind this work at the time: "I created my sculpture, the 'Mechanical Head', in 1919, and gave it the alternative title 'The Spirit of the Age', in order to show that human consciousness consists only of insignificant appurtenances stuck to it on the outside. It is actually only like a hairdresser's dummy head with attractively arranged locks of hair." For various reasons, doubt has since been cast on this early date of 1919. As the head was not exhibited at the "First International Dada Fair" held at Dr Otto Burchard's gallery in July 1920, scholars assume that it dates from later than this. Another circumstance which speaks in favour of this hypothesis is its affinity to the art of Italian Pittura metafisica, by which Hausmann was not inspired until the second half of 1920 at the earliest.

According to its creator, this work represents the "spirit of our age", in other words the atmosphere of the immediate post-war years. All the significant attributes of the object have been mounted by Hausmann on the outside of the head. The artist is introducing us to someone who only trusts in what he can measurably experience using objective equipment. In place of being felt expressively, the world is encompassed in precise fashion by means of the ruler, the mechanical clock and the camera. No credence is placed in anything but the printed word. All the information it might need is funnelled into the head through the beaker. By contrast, the head's own eyes remain vacant.

Following the "International Dada Fair", Raoul Hausmann became isolated from his fellow-Dadaists. In this situation, he discovered the metaphysical interiors of the Italian painters Giorgio de Chirico and Carlo Carrà. De Chirico's *manichino* figures (Italian *manichino* = model) had also lost all trace of individuality, having become part of a mechanical world of things. Hausmann took up this view of the world, as formulated in his *Mechanical Head*, once more, but from 1925 he devoted his time for a while almost exclusively to documentary photography and photo-technical experiments in the darkroom.

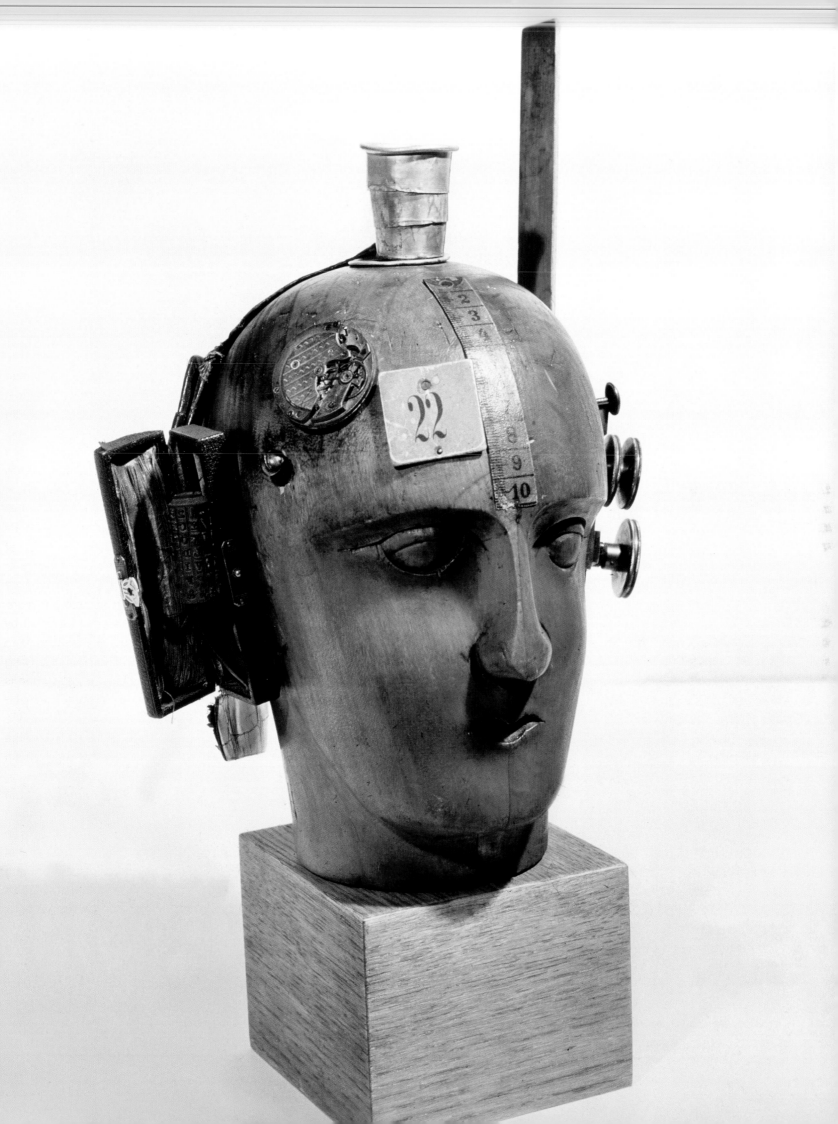

RAOUL HAUSMANN

ABCD

1923–1924, collage, 40.6 x 28.6 cm
Paris, Musée National d'Art Moderne, Centre Pompidou

In the middle of the second decade of the 20th century, while Raoul Hausmann was still moving in the circle associated with the Der Sturm gallery in Berlin, he attended a recitation evening given by the poet August Stramm, the power of whose Expressionist language he still remembered with fascination years later. The gallery also gave him an early opportunity to get to know Futurist poetry. The sound poems of the Zurich Dadaists, by contrast, were unknown to him, or at least so he said, when he started making his own experiments in this direction in 1918. In his own sound poems, Hausmann smashed the language up, isolated individual syllables, broke meaningful elements into pieces and re-assembled the scraps in a different order. Language was robbed of its communicative function; the sounds took on a life of their own; they had nothing more to say. The resulting sequences of sounds created for listeners a new, unfamiliar, acoustic experience. In his "opto-phonetic" poster poems, Raoul Hausmann linked this linguistic expression with a pictorial one. By printing the texts of his sound poems on large pieces of wrapping paper, he gave the sounds visual form. These works were designed to overwhelm the beholder-cum-listener visually and acoustically.

One of his best-known poster poems is the two-line *fmsbwtözäupggiv-..?mü*, which he recited at a joint Dada soirée with Kurt Schwitters in Prague in 1921. While returning from their appearance, Schwitters repeated Hausmann's short sequence of sounds, varying it and constantly extending it. In the following ten years, he developed out of it a more than forty-minute-long "Sonata in Elemental Sounds". Hausmann's original line is hardly identifiable in it, but nonetheless, he accused Schwitters of plagiarism. What annoyed Raoul Hausmann all the more, however, was that Schwitters had used his "language-busting" sound-poem on which to compose a traditional sonata in three movements, albeit with the "sound-painting" element retained.

The photomontage *ABCD*, dating from c. 1920 differs conspicuously from Raoul Hausmann's earlier collages. Here, he has not designed a uniform, perspective space for his depicted figures to move in. Instead, he presents the picture as a collage of different fragments of reality, different pictorial planes and perspectives. The central motif is a self-portrait of the artist as a photographic representation. Hausmann shows himself with wide-open mouth reciting his sound-poem *ABCD*. The four letters are veritably flung at the beholder. Hausmann's head is surrounded by isolated sequences of letters and figures. Each fragment is typographically different from the others.

The beholder can take in the picture without deriving any coherent sense from it. In one place only, on the right next to the artist, do four letters produce a coherent term, namely "VOCE", the Italian for voice. This foreign word can be seen as a hidden clue to the influence of the Italian Futurists on his sound-poems and his visual works. His friend Kurt Schwitters is also present in the work once more: "Raoul Hausmann as Emotional Margarine" and the word "MERZ" can be discerned on a stuck-on announcement. The description "emotional margarine" is to be understood as an ironic allusion to the art of the Expressionists. The announcement itself refers to the "First Great Merz Matinée" which Kurt Schwitters held jointly with Hausmann at the Tivoli-Theater in Hanover on 30 December 1923. The typography of the announcement was designed by the Russian Constructivist El Lissitzky, who was living in Hanover at the time. In the immediate vicinity of this announcement, Hausmann has stuck a Czech banknote as a souvenir of their appearance in Prague and also as an allusion to the origin of Schwitters' "Elemental Sonata" in Hausmann's *fmsbwtözäupggiv-..?mü*.

Poster poem "fmsb...", 1918

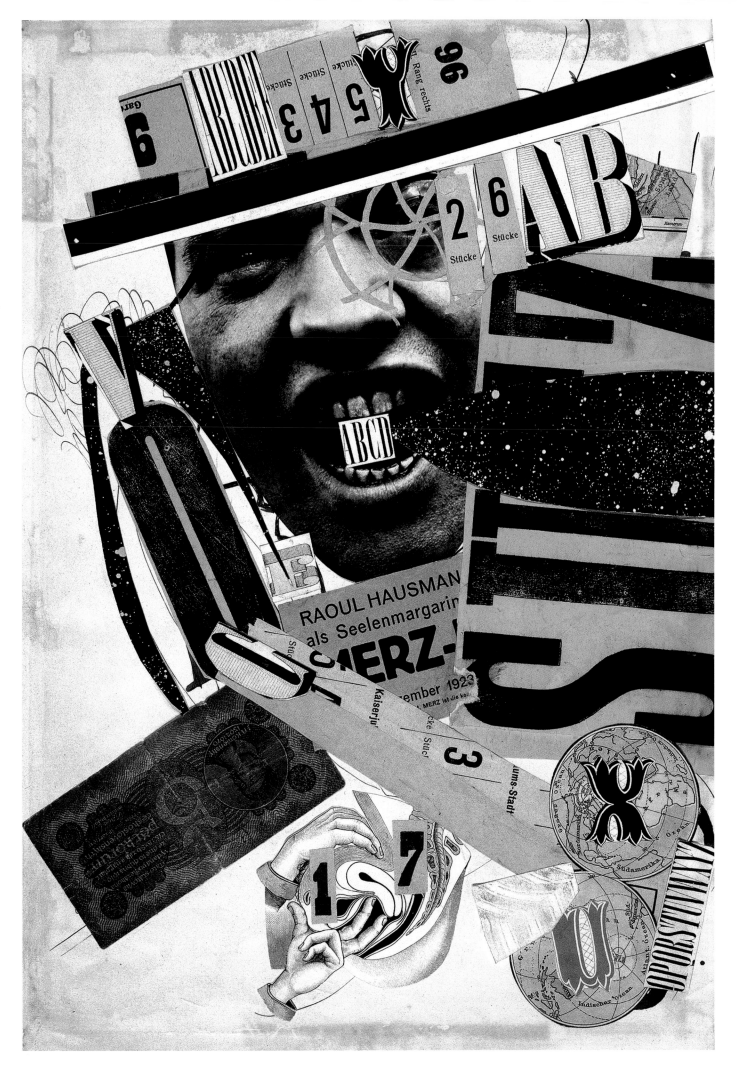

Da Dandy

1919, photomontage, 30 x 23 cm
Private collection

b. 1889 in Gotha, d. 1978 in Berlin

In 1912, Hannah Höch began to study at the Kunstgewerbeschule in Berlin. Later she transferred to the Staatliche Lehranstalt des Kunstgewerbemuseums. In 1915, during this period, she met Raoul Hausmann. Both were at that time associated with the circle centring on Herwarth Walden's gallery Der Sturm. Through Hausmann, she subsequently made the acquaintance of the Berlin Dadaists. Johannes Baader gave her the title "Dadasophess", a friendly allusion to her lover, the "Dadasopher" Raoul Hausmann. The "h" at the end of her first name was added by Kurt Schwitters in 1921, on the grounds that it made her name palindromic, like the Anna in his Merz poem "An Anna Blume".

At the Kunstgewerbeschule Hannah Höch had taken lessons chiefly in interior decorative design; consequently her earliest artistic works included abstract motifs with ornamental forms and repetitive patterns. By contrast, she had difficulty coming to terms with the anarchic actions and political demonstrations of the Dadaists. And while Hausmann constantly sought to give his artistic work some theoretical legitimacy, the Dadasophess for her part evolved a spontaneous, playful and elegant irony in her work.

The photomontage *Da Dandy* was created in 1919, and depicts a complex, many-layered arrangement of pictorial motifs. Like many of Hannah Höch's works, this one too deals with the theme of gender relationships and the role of women in modern society. The artist's day job at the time was as an archivist at the Ullstein publishing house in Berlin, which gave her unrestricted access to all the magazines, including some illustrated periodicals which were already propagating a new, modern feminine image. *Da Dandy* also alludes to her stormy relationship with Hausmann, which is also the subject of other works. The eponymous motif is of course Hausmann himself, whose appearance she was later to describe as follows: "The mere sight of a monocle in those days hurt the feelings of the petty bourgeoisie, who regarded themselves as progressive. But particular outrage ensued when a dandy from the Dadaist group, armed with a monocle, took the rostrum at a communist meeting."

Hannah Höch incorporated the title of her photomontage as a graphic element in the design. The work, however, centres on the silhouette of a head in profile, though at first sight it is difficult to recognize as such, since the artist has hidden it in the manner of children's puzzle pictures. This area is filled out with several motifs of young fashionable women in elegant clothing and extravagant hats. They smile seductively at the beholder. Höch has covered, and thus emphasized, this eye-catching motif with other people's eyes. The "Da Dandy" thus appears here to have his head full of nothing but women. In this sense, the work is key to an understanding of her relationship to Raoul Hausmann, who at the time was living both with his wife Elfriede and with Hannah Höch. As he had no intention of choosing between the two women, there was constant tension between him and Hannah. The work *Da Dandy* is an aloof but ironic reflection of this complicated relationship. The portrait of her lover is merely schematic, and is covered by depictions of the artist's numerous young rivals.

> **"I wish to blur the firm boundaries which we self-certain people tend to delineate around all we can achieve."**
> Hannah Höch

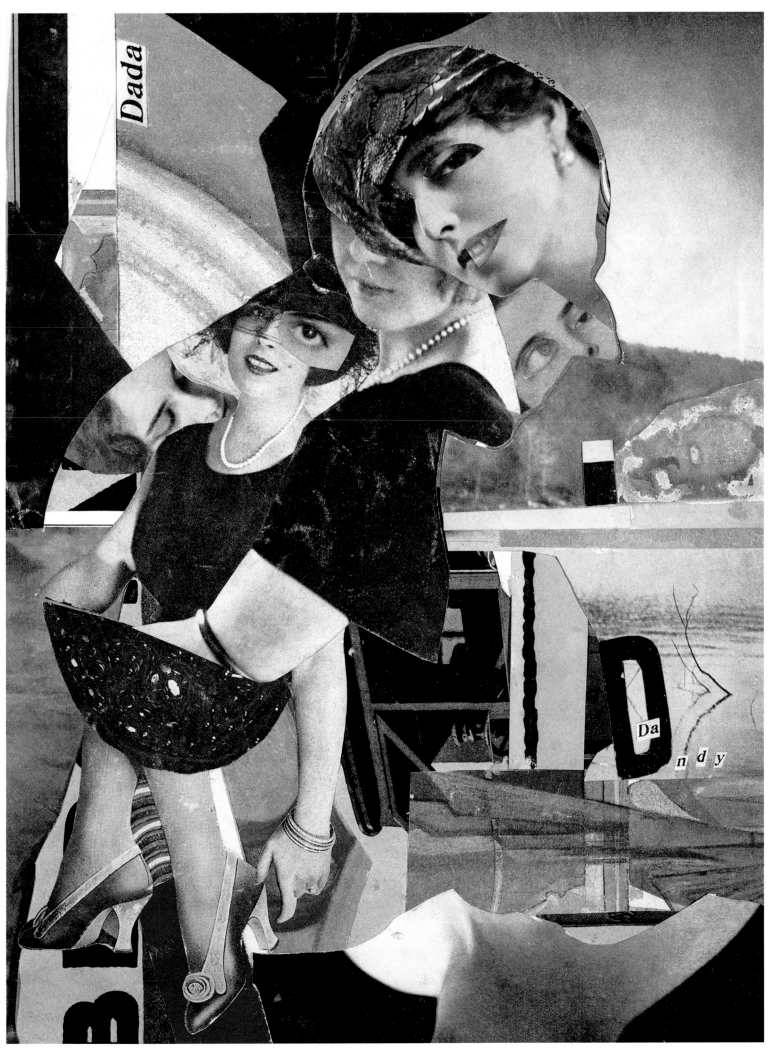

Incision with the Dada Kitchen Knife through Germany's Last Weimar Beer-Belly Cultural Epoch

1920, collage, 114 x 90 cm
Berlin, Neue Nationalgalerie

As the only woman in the Berlin Dada movement, Hannah Höch had no easy time of it. For all the proclamations of her male fellow-Dadaists in favour of emancipation, and their political support for equal rights and opportunities for the sexes, as an artist she was not taken seriously by most of the other Dadaists. A telling example of this attitude is the back-handed compliment paid her by Hans Richter in his book of memoirs "Dada Profile", in which he praises her talent in particular as the "hostess of the Hausmanns' studio evenings", at which she made herself indispensable by "managing somehow, in spite of the lack of money, to conjure up buttered rolls plus beer and coffee". George Grosz and John Heartfield only consented to her participation at the "First International Dada Fair" in 1920 after massive intervention by Raoul Hausmann. Hannah Höch took her revenge for this mistrust on the part of some of the male Dadaists by producing one of the most impressive exhibits on display. In the catalogue, her unusually large collage is entitled *Incision with the Dada Pastry Knife through Germany's Last Beer-Belly Cultural Epoch (Schnitt mit dem Kuchenmesser Dada durch die letzte Weimarer Bierbauch-kulturepoche Deutschlands)*, but the artist herself is listed as Hannchen Höch (a diminutive form). On a photograph which shows her together with Raoul Hausmann at the exhibition, the collage can be seen in the background.

The work is a splendid snapshot of the year 1920. Hannah Höch has interwoven countless details, figures, portraits, mechanical elements, cityscapes and textual exhortations into her collage. It depicts a situation of upheaval, chaos and contradiction. Thanks to the pictorial fragments' being arranged additively rather than compositionally, the work does particular justice to this prevailing atmosphere. Here we see the representatives of the old, toppled order: Kaiser Wilhelm II, who had abdicated, the crown prince, and Field Marshal Hindenburg. They are confronted by the representatives of the new order: Friedrich Ebert, the first president of the Weimar Republic, and Hjalmar Schacht, banker and later on president of the Reichsbank. Between we see sports personalities, actors, dancers and acrobats. Hannah Höch has in most cases taken the bodies of her "sitters" from a variety of pictorial sources. The result is a picture populated by clownlike, in some cases disfigured individuals. At the same time the work is a huge panopticon, in the middle of which some of the Berlin Dadaists can be seen at their anarchic tricks. Johannes Baader, Raoul Hausmann and Hannah Höch herself are not difficult to identify. Well-known Dadaist sayings, cut out by the artist from various publications, comment on the political chaos. At the bottom left-hand edge of the picture we can read the exhortation "Tretet Dada bei!" (Join Dada!), while elsewhere we see slogans such as "Invest your money in Dada!" or "Dada conquers!"

Alongside the personalities familiar from politics, the arts, sport and Dadaism, this collage also shows the image, characteristic of Dada, of a modern machine world. Diesel locomotives, a carriage of the Orient Express, automobiles and turbines, ball-races and gear-wheels are distributed over the entire surface of the picture, combining the individual scenes. At the same time, they set the entire tableau in motion. Among other details, we can recognize New York skyscrapers. With these motifs, Hannah Höch has composed a prophetic picture of a future Berlin, somewhere between a metropolis and a Moloch. The present title of the work, *Incision with the Dada Kitchen Knife (Küchenmesser) through Germany's Last Weimar Beer-Belly Cultural Epoch*, has a double meaning which is more obvious in German, where the word "Schnitt" (incision) can more easily also be related to the scissor cut-out by which the picture was created, as well as to the artist's incisive view: she is applying a surgical scalpel to the political events and upheavals of the time.

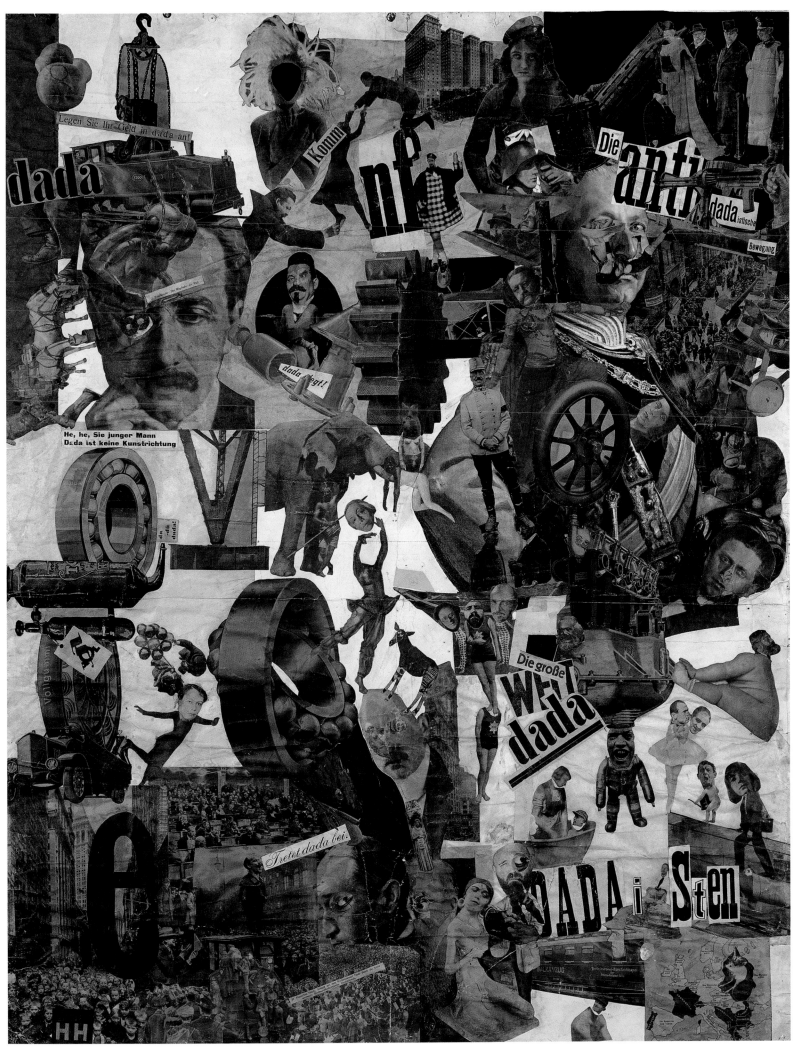

My Domestic Mottoes

1922, collage on cardboard, 32 x 41 cm
*Berlin, Berlinische Galerie, Landesmuseum für moderne Kunst,
Photographie und Architektur*

Hannah Höch was a collector. In her hidden-away sum-merhouse in her garden in the Heiligensee district of Berlin, she assembled numerous documents, materials, and records of Dadaism, arranged them according to a system comprehensible only to her, and thus preserved many ephemeral witnesses to the movement over the decades. After her death in 1978, the Berlinische Galerie acquired the archive and arranged it on more scholarly principles.

This 1922 collage *My Domestic Mottoes (Meine Haus-sprüche)* is also a collection of Dadaist souvenirs. The Dadasophess Hannah Höch was never a theoretician. She preferred to leave defin-itions of position to others, first and foremost her lover Raoul Hausmann. The collage also has room, however, for many other of her friends and fellow-Dadaists. *My Domestic Mottoes* is Hannah Höch's little ironic self-portrait as reflected in quotations from Kurt Schwitters, Hans Arp and Johannes Baader. The collage comes across as a sort of pin-board, on which the background is formed by various papers with decorative patterns, photographic depictions, scientific illustra-tions and a detail of a map. The mechanical motif of the ball-race appears here too. And once again she has not so much composed her materials as simply added them one after the other. As already in the *Incision with the Dada Kitchen Knife through Germany's Last Weimar Beer-Belly Cultural Epoch*, the beholder can find her self-portrait here too, hidden between the other elements of the collage.

On top of the papers stuck to the cardboard, Hannah Höch has written some pithy Dadaist slogans and signed them with the names of their authors. "Only an undecided mixture is dangerous" derives from Raoul Hausmann; "Let them say they don't know where the church tower stands" is a quotation from Kurt Schwitters' poem "An Anna Blume". And the insight "Dada polices the police" is due to Richard Huelsenbeck. It is through these slogans, carefully written out in neat handwriting, that the work gets its vitality.

By 1922 the Berlin Dadaist movement had already broken up. Its individual members had begun to go their own ways or to forge new coalitions. One such project in September of that year was the "International Congress for Constructivists and Dadaists", held at the Bauhaus in Weimar. Hannah Höch's personal relationship with Raoul Hausmann also broke up. In her *Domestic Mottoes* she had united all

the Dadaists once more: Hans Arp from Zurich, the Hanover Merz artist Kurt Schwitters, and the Berliners Richard Huelsenbeck, Walter Serner and Raoul Hausmann. She herself is looking somewhat shyly from behind a pale grid. The collage preserves those Dadaist mottoes which were to accompany her artistic work in the subsequent decades of her life. Even though in the future Hannah Höch was to devote much more of her time to painting once more, the principle of photomontage and collage continued to characterize her artistic output.

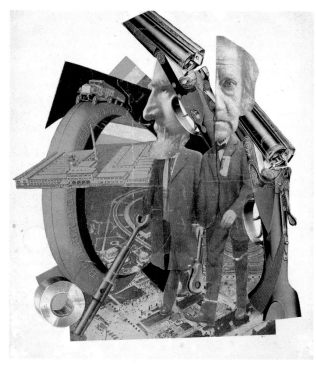

High Finance, 1923

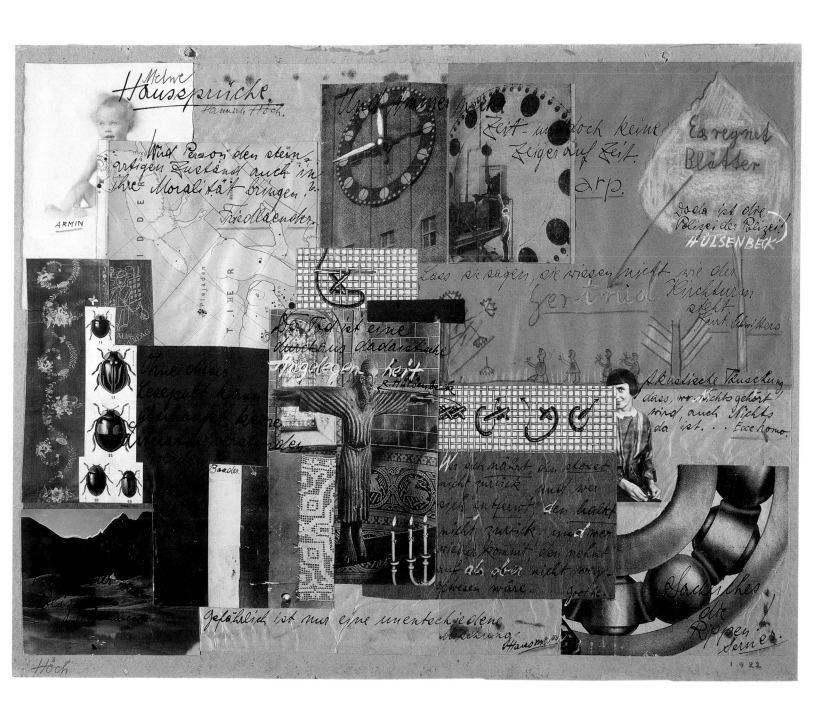

GEORGE GROSZ

The Guilty One Remains Unknown

1919, pen and Indian ink drawing, collage on cardboard, 50.7 x 35.5 cm
Chicago, The Art Institute of Chicago, Gift of Mr. and Mrs. Stanley M. Freehling

b. 1893 in Berlin, d. 1959 in Berlin

George Grosz was born as Georg Ehrenfried Groß in Berlin. Like John Heartfield, he anglicized his name in 1916 (the characteristic double-s or ß sign in German being technically "sz"), deliberately provoking those around him by speaking the language of the enemy. In 1914 he was one of the few artists who immediately recognized the madness of the war. Grosz had studied at the Kunstakademie in Dresden since 1909, at the same time observing the activities of the local Brücke group and those of the Blauer Reiter in Munich. From 1912, back in Berlin, while adopting the repertoire of forms and the colour dynamics of the Expressionists, he did not use them as the expression of an individual state of mind. This is why his actual medium was the drawing. By increasingly eliminating the expressive gesture from his depictions, and making his drawings more and more impersonal and unemotional, he hoped to arrive at an objectivization of the artistic statement.

The persons who appear in his works therefore never evince portrait-like features, but are only recognizable as representatives of their social class. George Grosz drew both the victims of the war and those who gained from it. He realized that the line between these two groups ran straight through the middle of the German people. On the streets of Berlin those crippled in action, along with beggars and prostitutes would encounter the well-fed middle-class who continued to pursue their pleasures, and the industrialists whose profits the war had only increased. Grosz understood his artistic work as a political struggle designed to arouse the beholder. "I drew and painted in a spirit of contrariness and tried to use my work to convince the world that it was ugly, sick and hypocritical."

George Grosz maintained a somewhat critical distance towards the first Dadaist activities in Berlin in 1918. Together with John Heartfield, he took up a radical political position, which he could not find in the Dadaist programmes that Richard Huelsenbeck had brought with him from Zurich. That he joined the German Communist Party at the same time as he joined the Club Dada, therefore, was doubtless no coincidence, but rather the logical consequence of this attitude. The other Dadaists nicknamed him "Propagandada".

This work, *The Guilty One Remains Unknown (Der Schuldige bleibt unerkannt)*, dates from 1919 and was exhibited at the "First International Dada Fair" held the following year. George Grosz here combines his sharp penstroke with the typical Dada collage elements, fragments of text commenting on the picture. The "guilty" perpetrator mentioned in the title dominates the foreground. A small printed figure is screaming "Treh-teh-teh! The Guilty One Remains Unknown" in his left ear. Grosz caricatures the perpetrator figure by giving him a broad, coarse face portrayed both frontally and in profile. With both hands and a greedy gesture, the "guilty man" grabs all the money he can and seems to be walking over corpses, as the word "Muerte" stuck over his left hand seems to indicate. The word "capitalist" is written obliquely over his almost bald scalp. In the townscape, partly drawn and partly composed of photomontage, we find the names of several international cities: Hamburg, Antwerp, Newcastle. On all sides in the conflict, Grosz believed, there were those who had done well out of the war. In the background of the picture a prostitute strides through the city streets. Her world is marked out by the two words "pimp" and "mission hotel". For Grosz, she is not only a victim of the emergency, but also a perpetrator, wielding power over her clients in her turn.

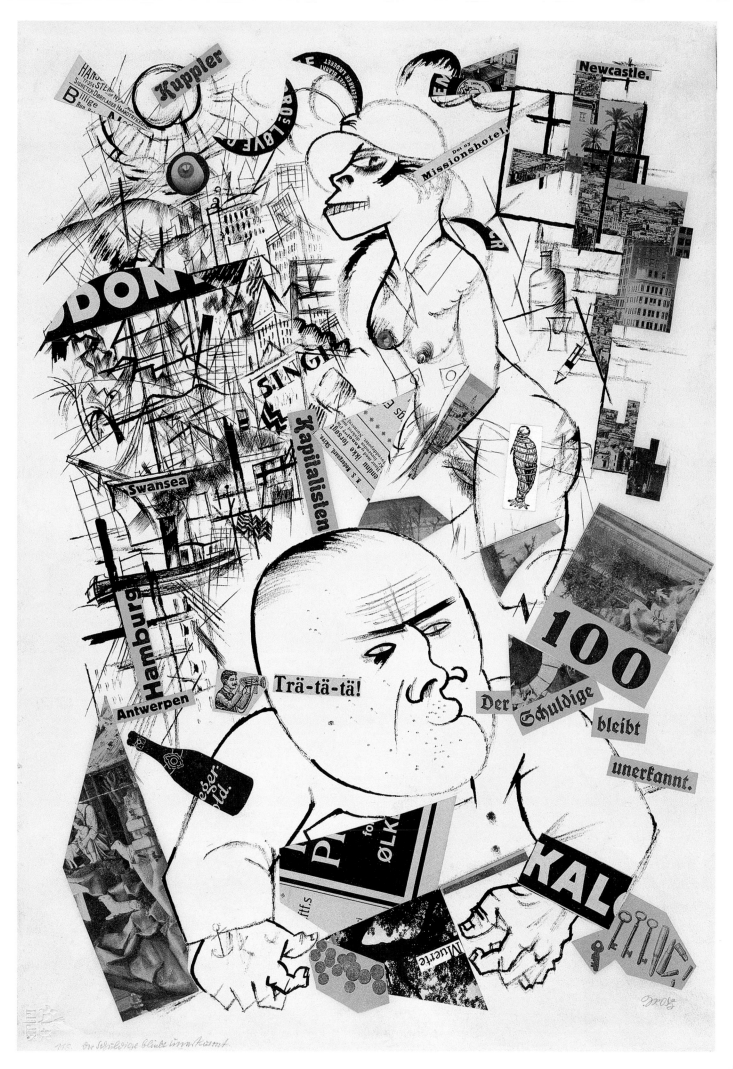

49

GEORGE GROSZ

Daum' Marries Her Pedantic Automaton "George" in May 1920, John Heartfield Is Very Glad of It
(Meta-mech. Construction after Prof. R. Hausmann)

1920, watercolour over pen and pencil, Indian ink, collage, 42 x 30.2 cm
Berlin, Berlinische Galerie, Landesmuseum für moderne Kunst, Photographie und Architektur

George Grosz met the brothers Wieland Herzfelde and John Heartfield (*né* Helmut Herzfelde) in 1915. Grosz' drawings later appeared in the magazines "Neue Jugend" and "Die Pleite", which were published by Wieland's Malik-Verlag. Grosz was not much interested in the traditional art market, and therefore sought to reach his public by alternative routes. He judged his drawings less by aesthetic criteria than by their political force. The publications of the Malik-Verlag provided him with the ideal platform for escaping from the limited circle of gallery visitors and addressing a broader public with his drawings. In addition he was fascinated by the credence accorded, immediately and without any apparent doubt, not only to the printed word, but also to the printed picture. "It said so in the newspapers, in other words, it must be true. I had respect for what was printed, and as I was printed too, I had respect for myself."

The watercolour with the original English title *Daum' Marries Her Pedantic Automaton "George" in May 1920, John Heartfield Is Very Glad of It (Meta-mech. Construction after Prof. R. Hausmann)* dates from 1920. The work was put on display under the same title shortly afterwards at the "First International Dada Fair". In the leaflet accompanying the exhibition, Grosz' publisher Wieland Herzfelde described the work in unusual detail. In the introduction he says: "The title is in English, because the work deals with intimate things that not everyone is intended to understand. Grosz is getting married! For him, though, marriage is not just a personal, but primarily a social event." Herzfelde also speaks of marriage as a "concession to society". The work shows Grosz' lover Eva Louise Peter, whom he married that year, as well as the artist himself as an anonymous mechanical puppet. "Daum" is an anagram of "Maud", his pet-name for his wife. In the top left-hand corner of the picture he has added her photograph. Grosz presents the two lovers in totally contrasting fashion: the female figure in realistic style, her genitalia drastically emphasized. The collaged man's hand gropes quite openly at her bared right breast. She casts her gaze seductively at the partner beside her. George Grosz depicts

himself as a mechanical figurine, devoid of any human features. Its body consists of mechanical gears which can be set in motion by means of a crank, and whose workings can be monitored by a number of gauges. In his description, Wieland Herzfelde also provided an explanation for the differential depiction of the bridal couple: "The symbol of the maiden is the naked figure covering her pudenda with her hand or the corner of some garment, but in marriage, there is no place for this denial of sexual need; on the contrary, it is emphasized. But it falls like a shadow between man and wife from the first hour of their nuptials: they see that at the very moment the woman can air her body and give free rein to her secret desire, the man turns his attention to other sober, and pedantic tasks. She is taken aback, and only shyly does she touch her husband's head as though it were some dangerous apparatus."

The male figurine points already to the influence of the Italian Pittura metafisica of Giorgio de Chirico and Carlo Carrà. Their *manichini* figures appeared, also for the first time in 1920, as anonymous jointed puppets in the works of Raoul Hausmann. The austerely perspective view of the architecture in the background of Grosz' picture is in addition reminiscent of the deserted Italian townscapes in de Chirico's paintings. For the French Dadaists, the example of Pittura metafisica had opened the way to their Surrealist pictorial worlds. In the case of Grosz and Hausmann, these influences were limited to a brief episode, without any lasting effect on their later artistic work.

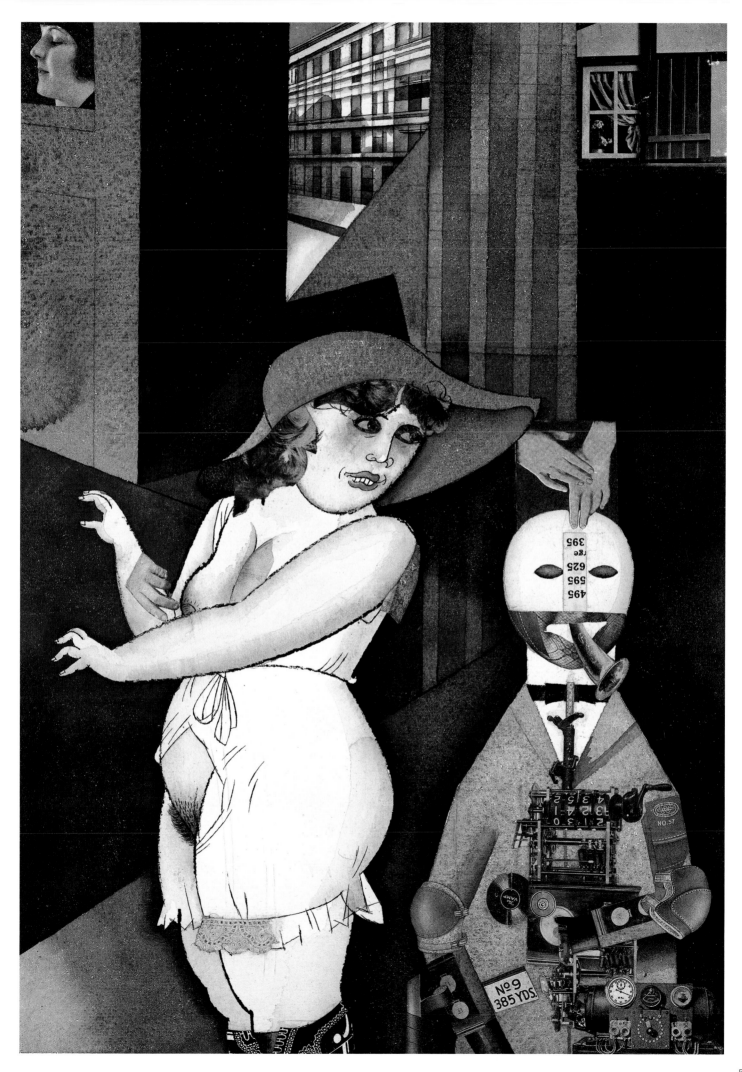

JOHN HEARTFIELD (in collaboration with George Grosz)

Sunny Land

1919, reproduction, original lost
Berlin, Akademie der Künste, John-Heartfield-Archiv

b. 1891 in Schmargendorf (near Berlin),
d. 1968 in Berlin (East)

John Heartfield (*né* Helmut Herzfelde) moved to the capital in 1913, together with his brother Wieland, who was five years younger. Hans Richter later recalled the brothers: "Wieland was as methodical, businesslike, more-brain-than-heart, as John was erratic, unpredictable and emotional." John anglicized his name after meeting George Grosz in 1915. Together they wanted to make a personal gesture against what they regarded as intolerable German jingoism. Thus Helmut Herzfelde became John Heartfield and Georg Groß became George Grosz.

Heartfield first wanted to become a painter. Landscapes were his preferred subject at that time. His meeting with Grosz changed his artistic outlook radically. They formed the "Grosz-Heartfield-Corporation" and together began to work on photomontages. They later quarrelled with Raoul Hausmann about who had first used the technique; Grosz dated their own invention of it to 1916: "In 1916, when Jonny Heartfield and I invented photomontage in my South End studio one May morning at five o'clock, neither of us had any inkling either of its great potential or of the thorny but successful path that this invention was to take." Certainly they took the technique further to its logical conclusion than did Hausmann, for they not only accorded the work itself a greater importance by replacing the painted depiction by a stuck-on fragment of a picture, but also redefined the artistic work process.

John Heartfield appeared exclusively in blue overalls, so that he was given the honorary title of "Monteurdada" (Mechanic-Dada) by his Dada friends. Joint photomontages such as the 1919 *Sunny Land (Sonniges Land)* were signed by Grosz and Heartfield not in handwriting, but with the printed text line "Grosz – Heartfield – mont." added to the collage. "mont." here is an abbreviation of "montiert",

which means "fitted", "installed" or "assembled", a formulation which points to the fact that they took industrial production processes as their exemplar. They quite expressly departed from traditional artistic techniques, and claimed that their activity was in character equivalent to the technical and mechanical production process. *Sunny Land* was "assembled" by them in the way that factory workers screwed together components. This photomontage is known today only in the form of a reproduction; the whereabouts of the original, if it still exists, are unknown. This is entirely in the spirit of Heartfield's work-principle: even in his later years, his motifs only attained their valid formulation by being mechanically reproduced.

The title *Sunny Land* is an almost cynical description of the motif. The two authors John Heartfield and George Grosz have created a confrontational dialogue between sentimental picture-postcard motifs and family photographs on the one hand, and contemporary (1919) newspaper cuttings on the other. "U-boat – England's death!", "Away with these workers' soviets!" and "Hunger! Civil War!" are interspersed between images of the Virgin and pictures of Sunday excursions. Against the dark background, the collage elements form only a loose structure. The artists have concentrated not on the total structure, but on individual details of the picture. Thus in the sentence "Nur am Rhein da will ich leben" (Only the Rhine – there's where I want to go) they playfully change the word "da" (there) to "dadada". Or else they dress up a guardian angel in a top-hat and give him the face of Gustav Stresemann, the future foreign minister and chancellor, and leader of the conservative political party, the Deutsche Volkspartei.

"War can only be combatted with the language of war."

John Heartfield

Grosz-Heartfield mont.

Sonniges Land

JOHN HEARTFIELD

Title picture "Der Dada 3"

1920, magazine, 23 x 15.7 cm
Berlin, Akademie der Künste, John-Heartfield-Archiv

At the "First International Dada Fair", held in Berlin in 1920, there hung on the wall of Dr Otto Burchard's art gallery a large poster with the photograph portrait of John Heartfield. He has cupped his hands around his mouth in order to amplify his message, namely: "Dada is great...". The sentence continues: "...and John Heartfield is its Prophet." On the white bar above and below the photograph, beholders were treated to further sayings of the "Monteurdada". "Down with art" and "Down with bourgeois mentality!" A further exhibit at the "Dada Fair", the ceiling sculpture *Prussian Archangel*, created jointly by him and Rudolf Schlichter, actually resulted in his prosecution for "insulting the German army".

Together with his brother Wieland Herzfelde and his friend George Grosz, John Heartfield represented the radical political wing of the Berlin Dadaist group. As Hans Richter put it, they stood "somewhat to the left of left". As early as 1918 Heartfield also joined the German Communist Party. The political nature of Berlin Dadaism was largely due to his initiative.

As a do-it-yourself publisher, Raoul Hausmann had already brought out two issues of the magazine "Der Dada". The third and final number, however, was published by the Malik-Verlag owned by Wieland Herzfelde, whom the other Dadaists called the "Progress Dada". The issue named its responsible editors as Groszfield, Hearthaus and georgemann. It was John Heartfield who put together the cover picture. Here too, the collage which he created as a basis for the work was, for him, not an autonomous work of art, but merely the basis for a printed cover. For Heartfield, the valid version consisted only in the mechanically duplicated reproduction of the work on the magazine cover. The stuck-together original was therefore disposed of without a thought once it had fulfilled its purpose. Like many Dadaists, Heartfield was concerned to break with the traditional claims of the artistic "original" and the "aura" of the work of art connected with it. Contemporary forms of artistic expression should, in their view, be geared to modern materials and the latest production techniques. Accordingly, for his collages, Heartfield had recourse to photographic sources and duplicated their motifs using industrial rotation-printing methods, with the result that there was no longer any unique original: in fact, the cheap reproduction was the original. For his Surrealist collage novels after 1929, Max Ernst used the same reproduction technique.

Heartfield's cover montage is less a composition than a powerful combination of overlaid fragments of texts and pictures. There is no ordering principle. The cut-out pieces of paper push into one another and thus formulate a number of obvious commentaries on Berlin Dadaism. The centre of the montage is formed by a large portrait of a screaming Raoul Hausmann, who founded the magazine in 1919. At the top centre there are four individual fragments of text placed close together. If they are read as a single sentence, they produce the statement "Hausmann dada Brüder Baader". "Brüder" means "brothers", and hence the text is an allusion to the close friendship and joint activities of the two Berlin Dadaists Hausmann and Baader. Elsewhere one can identify the word-combination "Circus Grosz". Small, but centrally placed, the beholder can see a formulation of one of the central Dada themes: "den Siegeszug über veraltete Anschauungen" (the triumph over obsolete views). In the spirit of a Dadaist panorama, the cover page provides an introduction to the personalities and world of motifs awaiting the reader of the following pages, only sixteen in number, of "Der Dada 3".

**"First International Dada Fair",
1920**

DᴇʀᴅAᴅʙa 3

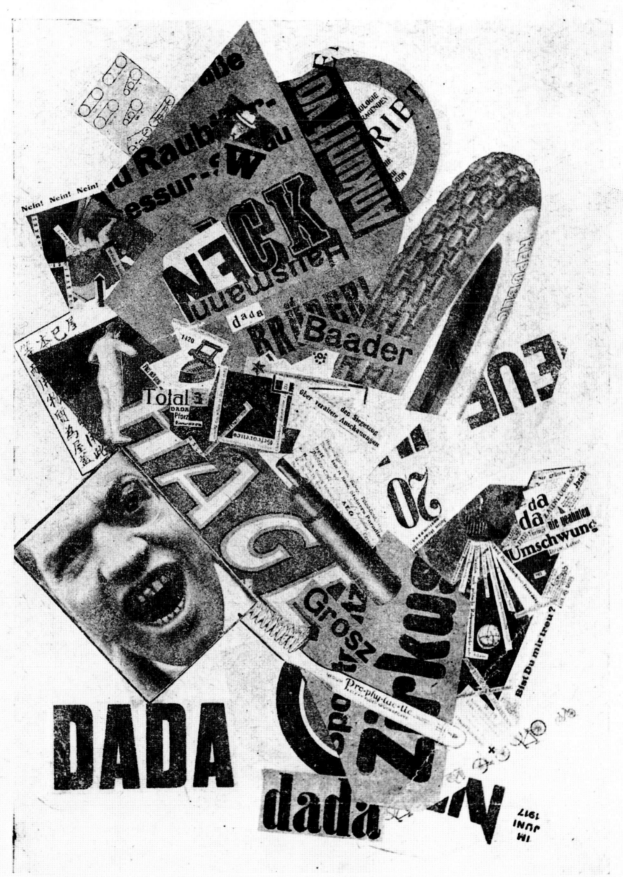

John Heartfield mont.

DᴇR mALiK-VᴇRLAG BER LIN aBTEILunG DAda

JOHANNES BAADER

The Author of the Book "Fourteen Letters of Christ" in His Home

1920, photomontage, 21.6 x 14.6 cm
New York, The Museum of Modern Art, Purchase. 275.1937

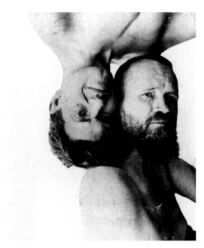

b. 1875 in Stuttgart, d. 1955 in Adelsdorf
Double portrait of Baader and
Hausmann, c. 1919/20

Johannes Baader studied architecture and is said to have designed, among other things, the rocks for the polar-bear enclosure in Hagenbeck's Zoological Garden. It was more by chance than anything else that he joined the Berlin Dada group. In 1918 John Heartfield and his brother Wieland Herzfelde discovered in him the born Dadaist, and introduced him to their friends. Herzfelde later reported: "Anyone could call themselves a Dadaist; they had to see to it that they did so. Some we discovered, for example a man certified as having diminished responsibility and was thus not culpable for his actions. We met him at our printer's during the first days of November 1918, where he was collecting the book he had written, 'Vierzehn Briefe Christi'. He introduced himself as the 'President of the Universe'. Immediately we took him to Grosz' studio, declared him to be the 'Oberdada' (Supreme Dada) and treated him in a correspondingly reverential fashion…"

The 1920 photomontage, stuck on to the page of a book, of Johannes Baader *The Author of the Book "Fourteen Letters of Christ" in His Home (Der Verfasser des Buches "Vierzehn Briefe Christi" in seinem Heim)* is designed as a self-portrait. In spite of this, there is no recognizable similarity between the figure portrayed and Baader's public image. The Dadaists honoured him as their Supreme Dada, as a figure who personified Dada in his lifestyle. Baader for his part used Dadaism and the publicity value of its actions in order to propagate his own extreme views. This is why he was controversial even within the movement — and quite definitely so when during the Dada tour of Prague in the spring of 1920 he suddenly disappeared with the day's takings.

Raoul Hausmann however always stuck by him, and photographs exist in which their heads seem almost symbiotically fused.

But their relationship was not without its tensions, as Hannah Höch reported: "From an early stage a friend — an enemy — a friend of Hausmann's. To start with, it was impossible to understand the associations in this man's essence, or his manifestations." Indeed, he took perfectly seriously the boastful title of "President of the Universe", with which he adorned himself even before being accepted by the Club Dada in Berlin. With his dense, dark beard, he came across as an obscure wandering preacher. He was an egomaniac and a self-appointed prophet, who formulated his claim to rule the world with unshakable conviction. In 1917 in Saarbrücken he stood unsuccessfully for the Reichstag. A year later, he even claimed to be above the National Assembly and declared: "Those who will not follow me as 'Christ', are welcome as friends of the 'Supreme Dada.'" The period of the war and the subsequent revolutionary unrest was one in which old traditions collapsed to leave a political vacuum. It was a climate in which a number of self-styled saviours and Führer-figures could flourish, Johannes Baader among them.

Baader had published his "Fourteen Letters of Christ" in 1914, styling himself as the reborn Christ. In this collage he presents himself through Dadaist role-play, as proclaimed by the stuck-on text "dada". However, he has substituted an advertising figure for his self-portrait. On its forehead it has an indecipherable sticker. It is a photograph of the figure which Baader that same year had created in his *Great Plasto-Dio-Dada-Drama*. In the clutter of his home, this well-dressed "author" seems, however, somewhat out of place. With his austerely parted hair, the twisted moustache and the uniform-like suit, he represents precisely that conservative middle class which the Dadaists otherwise held in such contempt.

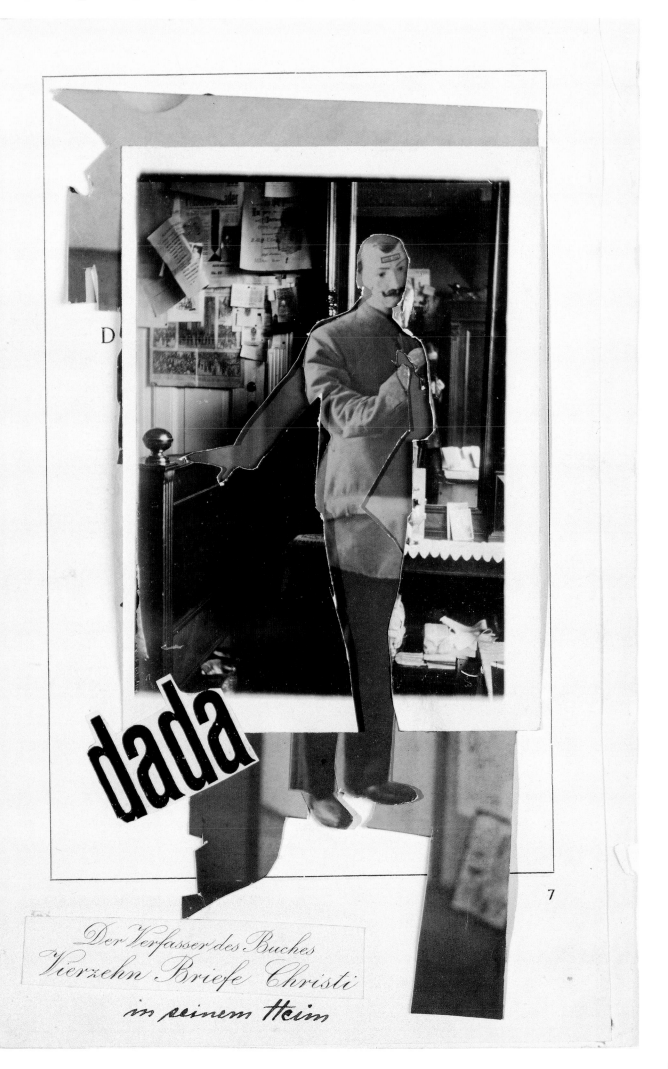

dada

Der Verfasser des Buches
Vierzehn Briefe Christi
in seinem Heim

The Great Plasto-Dio-Dada-Drama

1920, assemblage, no dimensions available (destroyed)
Photograph of the "First International Dada Fair"

Most of the Dadaists never appreciated the work of art as traditionally understood. Numerous pictures, collages and photomontages were created for particular occasions as poster designs, book illustrations or exhibition pieces, and subsequently ended up unceremoniously in the waste-paper basket. Accordingly, the artists attached no importance either to precise dating, or to titles. As a result, in the case of numerous surviving works, uncertainty exists as to when they were created, and sometimes there is more than one title. Indeed, titles are sometimes contradictory. This is true of Johannes Baader's most important work: *The Great Plasto-Dio-Dada-Drama: GERMANY'S GREATNESS AND DECLINE by teacher Hagendorf or The fantastical life-story of the Supreme Dada (Das große Plasto-Dio-Dada-Drama: DEUTSCHLANDS GROESSE UND UNTERGANG durch Lehrer Hagendorf oder Die phantastische Lebensgeschichte des Oberdada)*. The assemblage was created in 1920 for the "First International Dada Fair" at Dr Otto Burchard's gallery. After the exhibition had ended, the work was destroyed. All that has been preserved is a single photograph of the assemblage, along with a detailed description of the work by Baader himself in the "Dada Almanac" published a few months later. There, the various storeys of the tower are commented on as follows: "The cylinder soars into the sky and extols the glories of teacher Hagendorf's reading desk." In the exhibition leaflet, Baader was somewhat more ironic: "The cylinder screws itself into the sky and proclaims the resurrection of Germany through teacher Hagendorf and his reading desk." In fact, this "reading desk" is no more than a reading-aid for bed-ridden patients: Johannes Baader had worked briefly for the manufacturer.

The *Great Plasto-Dio-Dada-Drama* is a looming tower, a wood and cardboard-box construction, to which Baader has attached numerous posters, whole newspapers, among them the popular "BZ am Mittag" and the Dadaist "Die Pleite", a mousetrap, a woven basket, a section of stovepipe, a toy train carriage, and the advertising figure familiar from the photomontage *The Author of the Book "Fourteen Letters of Christ" in His Home.* As in the collage, it represents here too the self-portrait of the artist. Baader has divided the tower into five storeys, which are designated by large-format panels. On the photograph the figures 2 and 5 can be made out clearly. Each storey has a

particular theme assigned to it. "1st storey: the Preparation of the Supreme Dada; 2nd storey: the Metaphysical test; 3rd storey: the Inauguration; 4th storey: the World War; 5th storey: World Revolution." The text written by Johannes Baader to accompany the work turns out to be a model of explanation of the world, which goes somewhat over the top in its oscillation between irony and pathos, combining fragments of Baader's own biography, political splinters of the age and all kinds of culture-historical references. Thus on the assemblage in the second storey of the structure he says: "A museum of the masterworks of every century opens up under the twitching of the "old Germanic" mousetrap. Burst in two in the middle is the church, the third part having been demolished in accordance with its purpose and standing as a prison on Alexanderplatz (comfortable sojourns possible on all weekdays, Sundays, holidays, and putsch days)."

During the "Dada Fair", Kurt Schwitters came to Berlin a number of times, and took the opportunity to visit the exhibition. Baader's *Great Plasto-Dio-Dada-Drama* must have exerted a particular fascination on him, for – as evidenced by a photograph – he was already working at the same time on a similar, so-called *Merz Column* on which were stuck newspaper cuttings, posters, and fragments of objects, the whole being crowned with a doll's head. Following the example of the "Dada Fair" in Berlin, Kurt Schwitters also papered the walls of his Hanover studio with numerous poster texts and pictures, as well as pieces of newspaper.

"I am the President of the Cosmic Republic who speaks all languages in the universal tongue."
Johannes Baader

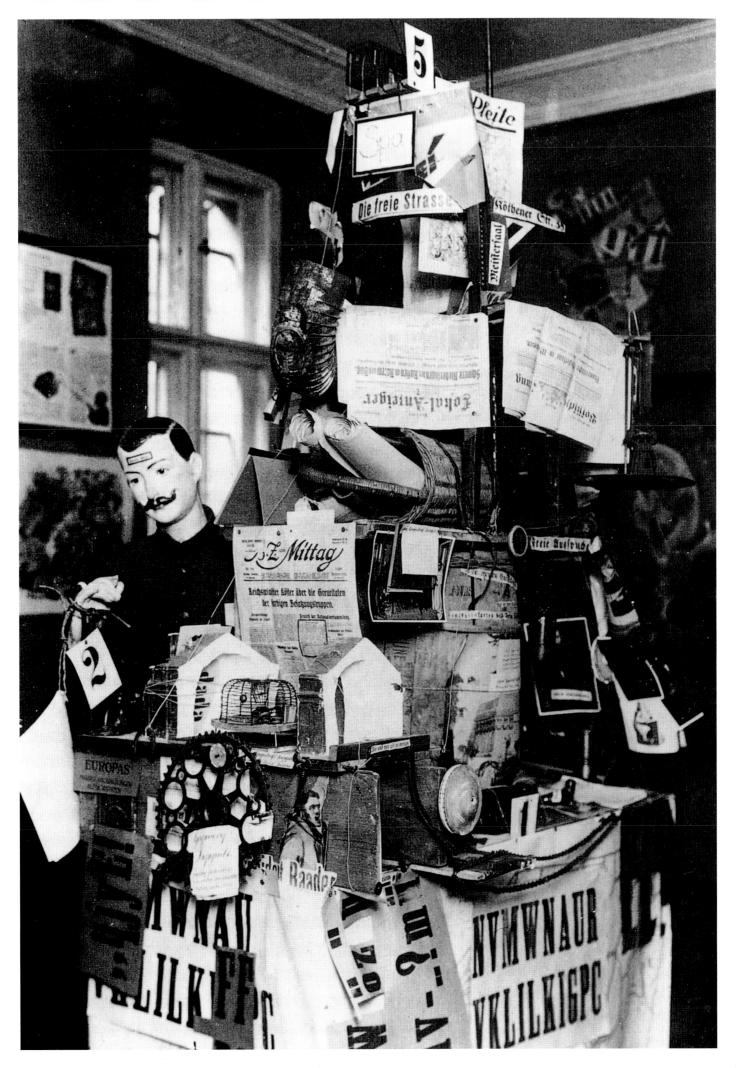

KURT SCHWITTERS
The Pig Sneezes to the Heart

1919, pencil and watercolour on paper, 25.9 x 20.5 cm
Hanover, Sprengel Museum, Kurt und Ernst Schwitters-Stiftung

b. 1887 in Hanover,
d. 1948 in Ambleside (GB)

In 1909, Kurt Schwitters left his native city of Hanover to study at the Königlich Sächsische Akademie der Künste (Royal Saxon Art Academy) in Dresden. But instead of using the course as a springboard into one of Germany's art centres, say Berlin or Munich, he returned to his provincial home city in 1915. Here in the post-war years he led the life of an avant-garde artist who camouflaged himself as a petty bourgeois. During his student years in Dresden, Schwitters seems to have taken no notice of the local group of Expressionist artists known as Die Brücke. Instead, he tried his hand at academic landscapes and portraits. Throughout his life, Kurt Schwitters never gave up this traditional form of painting, not only for commercial reasons but also seeing them as a necessary counterweight to his abstract collages and assemblages. He was indeed that "Caspar David Friedrich of the Dadaist Revolution" about whom Richard Huelsenbeck got so worked up. Schwitters however succeeded in balancing out all these contradictions in his life and work.

In 1918 Kurt Schwitters began to draw closer to contemporary developments in art. At first Expressionist and Futurist elements started to appear in his works. In 1919 he produced a small group of so-called Dadaist drawings painted over in water-colour. These included this work, *The Pig Sneezes to the Heart (Das Schwein niest zum Herzen)*, whose title takes up the absurd word-games played by the Dadaists. Schwitters was inspired to produce these works by Paul Klee, with whom he had exhibited in January of the same year at Berlin's Der Sturm gallery. On a spatially undefined surface, Kurt Schwitters here combines various motifs which have no logical connexion: a funnel, a hilltop, a pig, a bottle, an old man with a walking-stick, a male profile and a stylized heart. Schwitters once described his artistic technique at the time by saying that he was balancing sense against nonsense.

The individual motifs are items of a repertoire which crop up time and again in other water-colours in this group of works. Schwitters' drawing has been executed in fine pen-strokes and coloured in tender hues. The combination of motifs comes across as all the more absurd in view of this restrained presentation. Between the individual details there is no obvious association; the proportions are seemingly arbitrary. Schwitters uses his motifs as props which he places on the picture in unexpected juxtaposition. In the process, a poetic atmosphere is developed, which we also find in his poems written at this time. For the beholder, these works set in motion an associative process that follows no logical theme. The combinatorial technique works in a similar way to Schwitters' collages, which he developed the same year. And indeed, we see the same motifs once again in these works. Only the absurd title of the work has any justification in the picture itself, for the beholder does indeed see a pig sneezing to a heart. A pencil-drawn arc leads from the pig's right nostril through a funnel and a bottle direct to a red heart.

"You know exactly as I do what art is: it is nothing more than a rhythm. But if that is so, I shan't bother myself with imitation or the soul, but purely and simply produce rhythms with whatever takes my fancy: tramways, oil paints, wooden block – yes, now you're gawping like a blockhead!"
Kurt Schwitters

Das Schwein niest zum Herzen. K. Schwitters 1919
 Ag. 6

Untitled (May 191)

c. 1919, collage, 21.6 x 17.3 cm
Hanover, Sprengel Museum, Kurt und Ernst Schwitters-Stiftung

"Invest your money in dada! dada is the only savings bank that pays interest in the hereafter!"
Kurt Schwitters

In November 1918 Kurt Schwitters resigned from his job at the Wülfel ironworks in Hanover. The revolutionary workers' insurrections had by now reached even that provincial city, and for Schwitters, they primed the pump of his new art. "I felt myself to be free and had to shout my joy to the world. On grounds of thrift I took for the purpose only what I found, for we were an impoverished country. One can shout with bits of garbage too, and that's what I did when I glued and nailed them together. I called it MERZ, it was my prayer following the Victorious Outcome of the war, for peace had conquered yet again." That was how Kurt Schwitters assessed the dramatic situation later. In the autumn of 1918 he had just made the acquaintance of Raoul Hausmann, Hannah Höch and Hans Arp in Berlin. It was first and foremost Arp who inducted him in the pictorial technique of collage and it was doubtless for this reason that Kurt Schwitters presumably dedicated to him his first known collage *Drawing A2 Hans (Hansi)* in 1918. Among the materials used was the wrapping paper employed by the Dresden chocolate company Hansi-Schokolade. In other respects too, Schwitters preferred to use found materials for his collages, for example used tickets, advertising leaflets, old bits of cloth and details from newspaper headlines. Since 1919 he called all his collages *Merz drawings,* thereby setting them apart from his larger-format assemblages, the so-called *Merz pictures.*

Untitled (May 191) was probably created in 1919. It is a particularly good example of Schwitters' aesthetic way with his material and of his allusions to current political affairs. For the collage, he has used primarily pieces of paper with fragments of text, along with a few pieces of unprinted paper. The text fragments probably all derive from posters which Schwitters had removed from the advertising columns in the streets, something he liked doing. Unlike some Dadaists, Kurt Schwitters was an artist to the core, and good composition of his works was always important to him. This is true of this work with its rather modest format. The text serves first of all as a constructive element. The black bars and shapes structure the area of the picture. In the lower third they form a powerful base or plinth, while ascending vertically upwards in parallel lines in the middle of the picture.

It is always surprising to observe how Schwitters forever succeeds in fusing the manifold sources of his motifs and the disparate materials into a unity. In the collage *Untitled (May 191)* the individual pieces of paper were still being torn into irregular shapes by hand. Two years later, he came to prefer scissors and clean-cut edges. This was partly a consequence of his drawing closer to the international Constructivist movement. In this 1919 work, the individual snippets of paper are so closely interlocked that the result is a uniform surface in earthy beige and faded red. Only the powerful black printed letters are in hard collision.

Unlike the Dadaists in Berlin, Kurt Schwitters never saw himself as a political artist. But he did not exclude politics from his work. As an acute observer of his age from the perspective of Hanover, a provincial capital, he incorporated the current revolutionary events into his œuvre. These political tensions are visible in the way the scraps of text are juxtaposed. The clearly legible "Mai 191" fixes the events to a precise date. From the remaining identifiable text fragments, a number of key concepts emerge, which describe the revolutionary atmosphere in that May of 1919. We read of strikes and metalworkers' strikes, of electricity workers and businessmen, as well as of food, which was rationed in post-war Germany. This, too, distinguishes the Merz artist Kurt Schwitters from the Dadaists in Berlin. He was never an aggressive agitator, but always the silent, but all the more emphatic chronicler of his age.

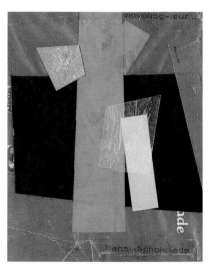

Drawing A2 Hans (Hansi), 1918

Kurt Schwitters

KURT SCHWITTERS

Merz Picture 29A.
Picture with Flywheel

1920, assemblage, 85.8 x 106.8 cm (picture),
93 x 113.5 x 17 cm (original frame)
Hanover, Sprengel Museum, Kurt und Ernst Schwitters-Stiftung

Since the summer of 1917, Kurt Schwitters had worked for more than a year for the Wülfel ironworks as a technical draughtsman. This industrial world of machines later found its way into his artistic work. In the first few years after the end of the war, he produced numerous works in which fragments of machines, wheels and discs occupy a central position in the composition. One of the most important examples of this group of works is the 1920 *Merz Picture 29A. Picture with Flywheel (Merzbild 29A. Bild mit Drehrad)*, which the artist revised slightly twenty years later. Unlike the more modest *Merz drawings,* for which he primarily used snippets of paper, in the *Merz pictures,* as he called his larger-format assemblages, he also employed three-dimensional materials. In *Merz Picture 29A* these include a lid, a piece of cotton-wool, a broken spoked wheel and an iron chain. Two parallel fragments of toothed wheels, extending from the left into the area of the picture, define the composition. All the other elements of the picture are oriented to them.

Unlike those in the *Merz drawings* dating from the same period, the *objets trouvés* used here have been painted over. The material construction spreads out against a blue background. The coloured setting of the objects often forms larger units and thus composes a number of elements into a single form, as can be seen particularly graphically in the large light triangle in the middle of the picture. The overpainting serves, first and foremost, the purposes of the total composition and stops the work becoming a mere addition of many small objects on a large surface.

Merz art has always allowed observation and interpretation on a number of levels. As early as 1919, Kurt Schwitters realized that it could be taken as purely abstract art, whose materials possess nothing more than their own values in respect of shape and colour. In the programmatic text on *Merz painting*, he says accordingly: "The Merz paintings are abstract works of art. The word Merz means essentially the summarization of all conceivable materials for artistic purposes, and technically the – on principle – equal valuation of the individual materials… In Merz painting the box-lid, the playing-card or the newspaper cutting becomes the surface, the string, the brush-stroke or pencil-stroke becomes the line, the wire-net, the overpainting, or the stuck-on greaseproof paper becomes the varnish, and cotton-wool becomes the softness."

Schwitters not only dissolves his alien materials in abstract shapes, however, but at the same time allows his *objets trouvés* an illustrative function. The *Merz Picture 29A* thus also presents itself to the beholder as the depiction of a monumental factory hall, in which huge cog-wheels and pulleys drive the machines. The quartered rectangular shape, in the top centre of the picture, comes across as the window of a building, graphically illustrating the proportions of the huge machines. However, there is no sign of the enthusiasm for technology which characterized the Italian Futurists. Schwitters' machine-park comes across, if anything, as out-of-date, partly defective, and seems to be producing nothing. It is his ironic response to the mood of the times, whose enthusiasm for modern technology was in stark contradiction to the prevailing political chaos. With a scrap of paper on which is written his address in Hanover, Kurt Schwitters has introduced himself into the composition. Hemmed in by cog-wheels and pulleys, the artist seems to be in the process of being ground between the wheels of a gigantic machine.

In addition, Kurt Schwitters has also given this mechanical construction a political interpretation. Not, it is true, explicitly and openly, but hidden in a clue which he notes on the reverse of the work: "Instructions for use. From the position where the centre points vertically downwards, the wheel must only be turned to the right, until the right-hand spoke is pointing vertically upwards. It is forbidden to turn the wheel to the left. Kurt Schwitters. 5. 8. 1920." Thus his ironic commentary on the political struggles between the conservative parties and the socialists.

Construction for Noble Women, 1919

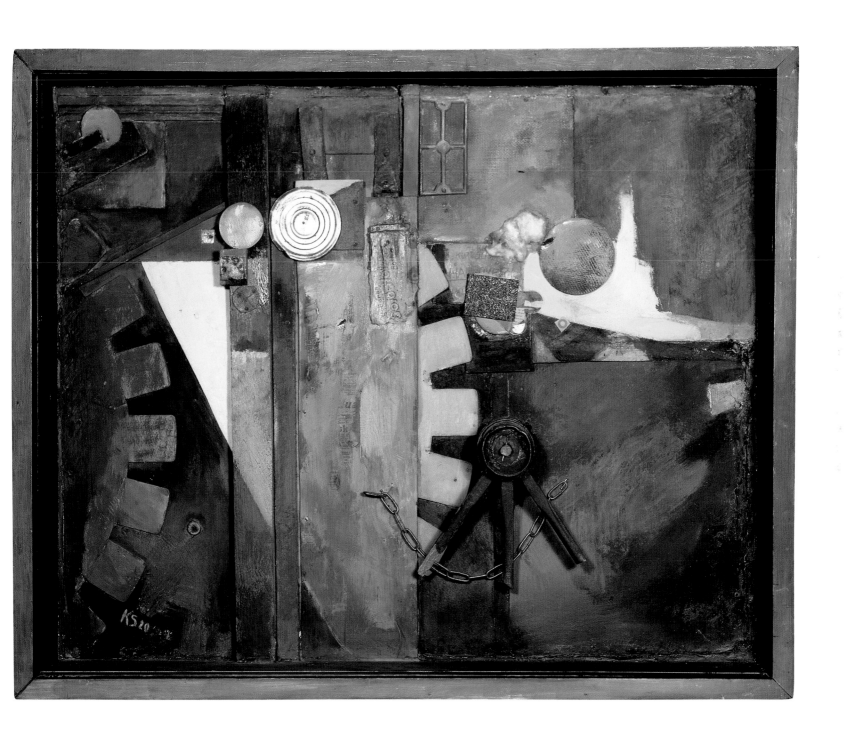

KURT SCHWITTERS

i-drawing

1920, offset print on paper, 11 x 8.7 cm
Hanover, Sprengel Museum, Kurt und Ernst Schwitters-Stiftung

**"When lions roar gazelles go still.
The hyenas sniff but the arts fulfil."**

Kurt Schwitters

"Everything is correct, but also the opposite," wrote Kurt Schwitters to his lover Käte Steinitz, and in so doing, adopted for his own Merz art the typical contradictions of the Dadaists. 1920 saw the appearance of the first of a small group of works in which Schwitters further radicalized the collage principle. Only at first sight do these works seem to be collages, but here the motifs are not composed of individual fragments of paper stuck together. Rather, the motif arises from the mechanical pressure of different starting-materials one on top of the other. Kurt Schwitters found the material for these works in the waste-bins of printing-presses in Hanover. They are pieces of what printers call spoiled sheets. What Schwitters found in them were so to speak *collages trouvés*. He called these works *i-drawings*. What matters is not any pictorial design on the part of the artist, but merely his selection of the correct detail – the dot on the i, as it were. The aesthetic process is thus restricted to creating the picture. The motif is first cut out and then stuck on to a piece of card and signed by the artist. "The creative artistic component here is the recognition of rhythm and expression in part of nature. For this reason there are no possible losses due to friction, in other words no distraction during the creative process," was how Kurt Schwitters characterized the particular charm of these *i-drawings* in a manifesto.

The untitled *i-drawing* illustrated here dates from 1920 and is a particularly dense and yet contrast-rich picture, whose colours stand out in brilliant clarity from the light background. Textual, pictorial and iconic elements overlay one another to produce a complex structure. Like a close-meshed grid, the horizontal and vertical lines of text place themselves across the picture. Beneath them the bold red numbers glow, repeating themselves at regular intervals and thus rhythmicizing the picture surface. The illustration of a gabled house can also be seen in a number of places beneath the textual structure. Schwitters later transferred the principle of the *i-drawings* to other artistic genres. Thus he composed a few *i-poems*, in which he used text fragments he had found, and in 1923 he published the second issue of his "Merz" magazine as a so-called i-number.

In the *i-drawings,* the artistic creative process of inventing and depicting a motif is reduced to finding a specific pictorial quality within an existing supply of motifs. From the multitude of existing potential

starting-materials, Kurt Schwitters regards it as his artistic task to specify the detail which in isolation will function as an autonomous and aesthetic pictorial composition. A comparison with Marcel Duchamp's concept of the ready-made may suggest itself, but the resemblance is merely superficial. With his ready-mades, what Duchamp did was to remove everyday objects from their natural surroundings, free them from their function, and display them on plinths as works of art in exhibitions. The result is a salutary provocation of the beholder's unthinking habits in the matter of the perception and evaluation of art. While Kurt Schwitters has recourse to similarly alien material – alien, that is, to art –, he seeks by delimiting a part of the object and emphasizing it as a compositional structure to bring it back to traditional art. Here we see taking effect the aesthetic principle that characterized his whole œuvre and opened up such an unbridgeable gulf between him and the anti-art of the Dadaists. Not least for this reason, Schwitters' Merz art survived the end of Dada almost unchanged.

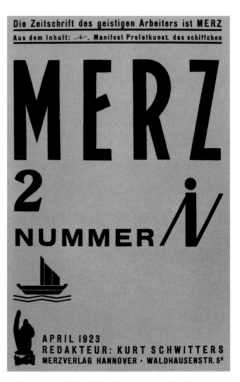

Title-page of the "Merz" magazine No. 2
(i-number), 1923

Kurt Schwitters.

i = Zeichnung

MAX ERNST

Fruit of Long Experience

1919, relief, wood and wire, painted, 45.7 x 38 cm
Private collection

**b. 1891 in Brühl (near Cologne),
d. 1976 in Paris**

As an artist Max Ernst was self-taught. He had studied art-history, philosophy and psychology in Bonn. In 1919 Max Ernst, together with Johannes Theodor Baargeld founded the Cologne offshoot of the international Dada movement under the title "Dada Conspiracy of the Rhineland". After the dissolution of the Zurich group, they were joined by Hans Arp. In his "Biographical notes", Max Ernst reports enthusiastically of his arrival: "Joy in the Dada house. A few days later it spreads like wildfire through holy Cologne: Arp is here! Conspiracy in the Dada house on Kaiser-Wilhelm-Ring, foundation of the W/3 Centre. W for West-stupidities, 3 for the three conspirators: Hans Arp, J. T. Baargeld and M. E." Max Ernst had met Arp back in 1914 at the Feldmann gallery in Cologne.

Fruit of Long Experience (Frucht einer langen Erfahrung) dates from 1919. The title is an ironic allusion to the labour of the creative process. The wood relief is reminiscent of Kurt Schwitters' *Merz pictures* of the same period, although Ernst cannot have known of them at the time. In his œuvre, these montages form a small group of objects which were made in the same year. A second construction with the same title carries by way of explanation the inscription "Sculpto-Peinture".

For Max Ernst, then, these works are hybrids between sculptures and paintings. As in the case of Schwitters, the wood assemblage, while it has figurative qualities, can also be regarded as a purely abstract composition. Max Ernst has taken various wooden elements, all of which previously fulfilled some other function, painted them and mounted them on a rear wall. On the left and right-hand edges of the picture, the vertical wooden elements stand out like buildings. In the centre, there looms a kind of chimney against a pale, yellowish sky. Max Ernst has joined up a number of white dots on this surface with lines, so that they come across as conventional representations of the constellations. At the bottom right plus and minus signs and a rising mesh of wire mark the energy exchange between the two opposite poles. Max Ernst's wood relief, screwed together as it is, represents an anonymous industrial landscape which has been reconstructed in makeshift fashion from the ruins of the war.

As a result of the identical painting, the frame of the wood construction here is more than just a frame for the picture, forming as it does a thematic unit with it. In this way the relief can be recognized as a work which deals with the artistic process itself. The *Fruit of Long Experience* marks for Max Ernst the climax of the centuries-long artistic development of the traditional panel picture, and yet at the same time stands for the fact that it has now at last been outgrown. Ernst ignores the functional associations of his starting materials, and gives the wood fragments in his sculpture-painting a new identity within the depiction.

Although he uses the lofty title to create an ironic aloofness from the wood construction, the *Fruit of Long Experience* stands among other things for an artistic paradigm shift. The collage principle, which also characterizes this work, would indeed become the new driving aesthetic design concept which would give a decisive impetus to the art of the 20th century.

**"Art has nothing to do with taste.
Art is not there to be tasted."**

Max Ernst

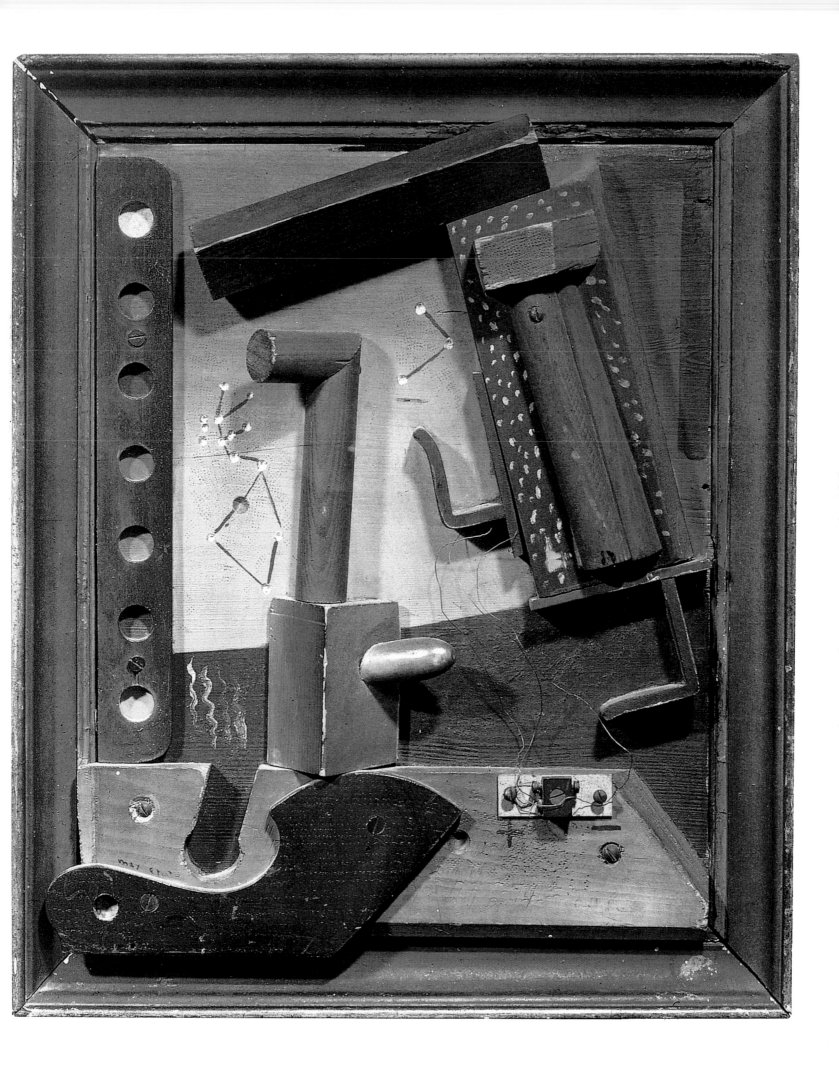

the master's bedroom it's worth spending a night in it

1920, collage, gouache and pencil on paper, 16.3 x 22 cm
Private collection

Alongside the Spanish painter Salvador Dalí, Max Ernst was one of the most prominent artistic personalities in the Surrealist group in Paris. In 1922 he moved definitively to the French capital, and joined the movement that had formed around their spokesman André Breton, who had also previously been a Dada sympathizer. As a Surrealist, Max Ernst was the inventor of numerous pictorial techniques, so-called semi-automatic techniques, which, as he once explained, gave impetus to his imagination. The use of frottage, grattage or decalcomania produced on the pictorial surface random structures, from which Ernst developed his figurative or landscape motifs. In other examples he took pictorial material which he found and re-combined to form surprising, unconventional motifs. Wooden printing-blocks of individual letters, 19th-century engravings, or scientific illustrations from text-books were just the sort of material which he liked to employ.

Some of these design techniques already turn up during Max Ernst's Dadaist works dating from 1919 and 1920. The transition to his later, typically Surrealist pictures was almost seamless. At least with hindsight, what we see is not so much a caesura between the work of Max Ernst the Dadaist and Max Ernst the Surrealist as an increasingly visible distance between his own Dadaist collages and the works of the Berlin Dadaists of the same period. Unlike the works of Raoul Hausmann or Hannah Höch, Ernst's collages are not abstract montages of picture and text which reflect a particular image of the atmosphere or of the age, but representations which go together to form a uniform, albeit at the same time totally absurd, spatial situation.

The small-format 1920 work entitled *the master's bedroom it's worth spending a night in it (das schlafzimmer des meisters es lohnt sich darin eine nacht zu verbringen)* is in this sense a typical Max Ernst pictorial construction. It depicts a low windowless room with floorboards, accommodating a number of unlikely inhabitants. The bedroom alluded to in the title is suggested by the bed at the right-hand edge of the picture. Next to it there are a cupboard and a table set for a meal, but also a whale, a small fish, a bat, a snake, a sheep and a bear. The mutual proportions, however, are all wrong. The whale seems tiny, and to be swimming in the floorboards, the bear is

gigantic. What appears as a collage of isolated pictorial elements has in fact merely arisen by dint of the intervention of the artist, who has covered some of the motif originals with paint.

Altogether in the spirit of his later Surrealist pictures, Max Ernst reported on how these motifs came about: "On a rainy day in Cologne on the Rhine, the catalogue of an educational-supplies store aroused my attention. I saw advertisements for models of all kinds, mathematical, geometrical, anthropological, zoological, botanical, anatomical, mineralogical, paleontological, and so on. Elements of such different natures that the absurdity of the way they were heaped together was confusing to the eye and to the senses, engendering hallucinations, giving the depicted articles new, quickly changing meanings. I felt my 'visual capacity' suddenly so intensified that I saw the newly-arisen objects appear against a new background. To capture this, all that was needed was a little colour and a few lines, a horizon, a desert, a sky, a boarded floor, and suchlike. Thus was my hallucination 'fixed'." Such techniques, where he captured vague hallucinatory impressions in painting and made his visual impressions more precise, formed the style for Max Ernst's entire Surrealist œuvre. To this extent he applied techniques he had already used in his Dadaist work, several years before André Breton published the "First Surrealist Manifesto" in Paris in 1924.

Catalogue of the "Kölner Lehrmittel-Anstalt",
page 142

das schlafzimmer des meisters es lohnt sich darin eine nacht zu verbringen

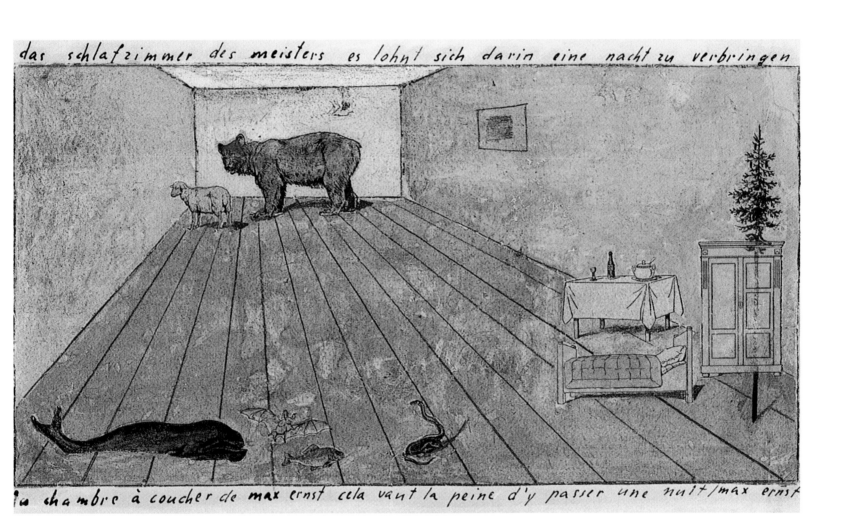

la chambre à coucher de max ernst cela vaut la peine d'y passer une nuit / max ernst

MAX ERNST

little machine constructed by minimax dadamax in person

c. 1919/20, pencil and ink frottage, watercolour,
and gouache on paper, 49.4 x 31.5 cm
Venice, Peggy Guggenheim Collection –
The Solomon R. Guggenheim Foundation, New York

Together with Hans Arp and Johannes Theodor Baargeld, in 1919 and 1920 Max Ernst published a number of Dadaist magazines, most of them short-lived. All the publications in Cologne were subject to censorship by the occupying British forces, and although the Dadaists here, unlike those in Berlin, were not conducting any explicitly political agitation, they nevertheless had to struggle with the censorship authority, albeit cunningly reacting to its prohibitions by continually founding new journals. After "Der Ventilator" was closed down, the Cologne Dadaists founded the magazines "Bulletin D", "Die Schammade" and later "Querschnitt". All these publications were produced at the Max Hertz art printing works. It was here too that Max Ernst found the originals for his collages and frottages. The magazine titles and his own contributions he illustrated for preference with technical drawings he had simply picked up, or else with printed letters assembled into pictures.

In the picture *little machine constructed by minimax dadamax in person (von minimax dadamax selbst konstruiertes maschinchen)*, which dates from 1919/1920, Max Ernst combines various artistic techniques and colour materials, which provide convincing evidence of his creative inventivity. For this, he used existing printing blocks of individual letters which he found in the printing works. He either pressed them against the sheet of paper, or transferred them to the paper on the frottage or brass-rubbing principle: placing the paper over the contoured object, and creating the image by rubbing the paper with a soft pencil.

In the case of the work *little machine constructed by minimax dadamax in person* the bars and letters were combined, and coloured with Indian ink and water-colour, in such a way as to produce in the eye of the beholder the impression of a rickety technical structure. The most striking detail is a protruding phallic tap halfway up the picture, from which a red drop with the greeting "bonjour" is emerging. The surprising function of this construction was revealed by Max Ernst in a detailed description at the bottom edge: "little machine constructed by minimax dadamax in person for fearless pollination of female suckers at the start of the menopause and similar fearless tasks". The artist has signed the work with his Dadaist pseudonym "dadamax ernst". As already in the *master's bedroom*, the choice of

title is not without sexual allusions. In this respect, many of his works resemble those of Marcel Duchamp. Even though the two artists did not yet know each other personally in 1920, works such as Duchamp's alienated Mona Lisa *L. H. O. O. Q* dating from 1919 or *The Large Glass (The Bride Stripped Bare by her Bachelors, Even)*, on which he had worked since as far back as 1915, must have been familiar to Max Ernst.

In 1920 Max Ernst was represented with several works at the "First International Dada Fair" in Berlin. Together with numerous other exhibits, his contributions were due to be exhibited subsequently at the Société Anonyme in New York. Allegedly however the ship with all the works on board sank on the crossing. Whether there is any truth in the story or whether it is merely a Dadaist legend, remains uncertain to this day.

Dada-Degas, c. 1920/21

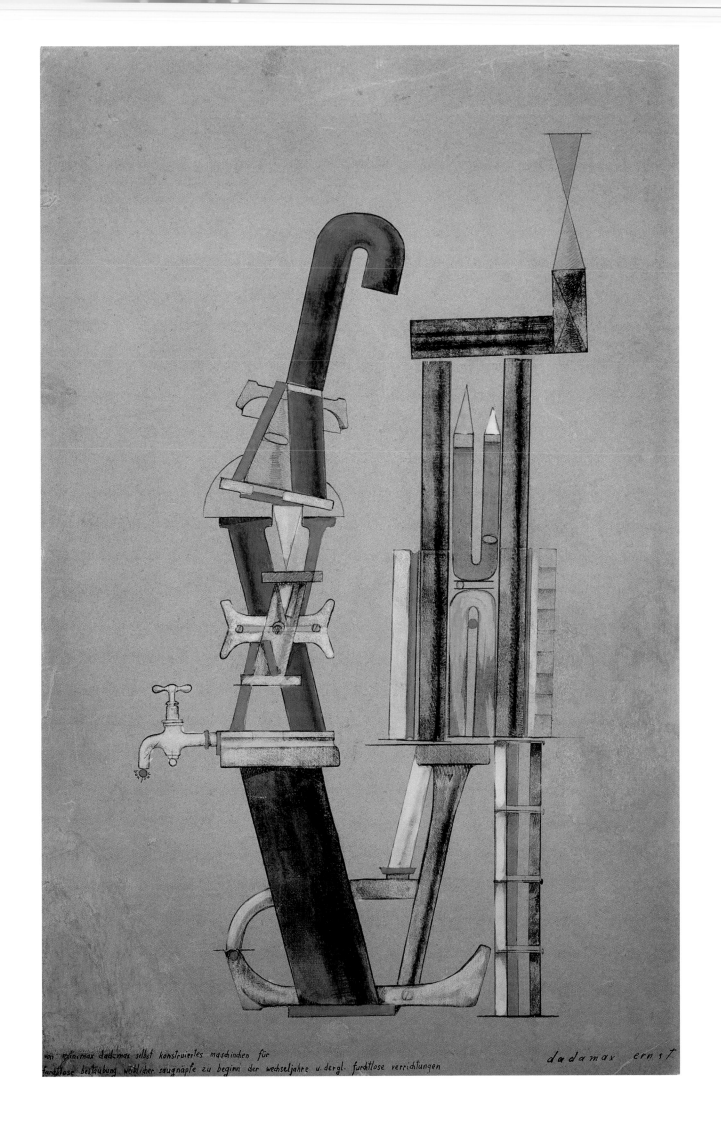

von minimax dadamax selbst konstruiertes maschinchen für
farblose bestäubung weiblicher saugnäpfe zu beginn der wechseljahre u. dergl. furchtlose verrichtungen

dadamax ernst

the chinese nightingale

1920, photomontage, 12.2 x 8.8 cm
Grenoble, Musée de Grenoble

In his autobiography, Max Ernst noted under the year 1919 a definition of the collage which differed in major respects from that of the Berlin Dadaists: "Collage technique is the systematic exploitation of the chance or artificially provoked confrontation of two or more mutually alien realities on an obviously inappropriate level – and the poetic spark which jumps across when these realities approach each other." Ernst only wrote this definition some years later, for it places his collage technique very close to Surrealism, which defined itself, on the basis of a text by Lautréamont, as "the chance encounter of an umbrella with a sewing-machine on a dissecting table". Nor would any other Dadaist, let alone one from Berlin, have dared to use a term like "poetic" in order to describe the effect of his photomontages.

1920 and 1921 saw the appearance of a small group of photomontages, whose starting material, at least, possessed no such poetic qualities. For these works, Max Ernst used photographic reproductions from popular scientific books on the recently ended war, which were largely concerned with military technology.

Ernst's motif *the chinese nightingale (die chinesische nachtigall)* is based on one such illustration of a bomb. He himself had served in the field artillery throughout the war. "Howling, cursing, puking are no help," he later wrote of his experiences at the front. He therefore could only react with disgust or Dadaist irony to the books that appeared immediately at the end of these terrors praising the technical achievement and progress in weapons technology and air power.

After Max Ernst's treatment of the original, the bomb lying in the grass is hardly any longer recognizable as such, all the more so as he has rotated the depiction through 90°. The attachment for the bomb can thus easily be re-interpreted by the beholder as the beak of a nightingale. It presents itself as a chimera of man and beast with human arms and eye, a fan as decorative head-dress and an elegant white scarf.

Max Ernst is here applying the same principle that was to be characteristic of his later Surrealist works. A hint discovered in the starting material (here it is the attachment, which, when he rotates the picture, protrudes from the object like a beak) is further developed and clarified. Finally, Ernst photographs and enlarges the photomontage. This evens out the different tones of the papers used and the interfaces between the various pictorial sources. The total impression is more homogeneous and the collaged motif gains in photographic realism.

Max Ernst borrowed the title of the work from the fairy-tale of the same name by Hans Christian Andersen. The theme of the story is a competition between a mechanical and a real nightingale as to which of them should rescue the life of the king with its song; in Max Ernst's picture, we have a war machine which is deprived of its lethal effect by being transformed into a peaceful "Chinese nightingale".

the chinese nightingale, 1920

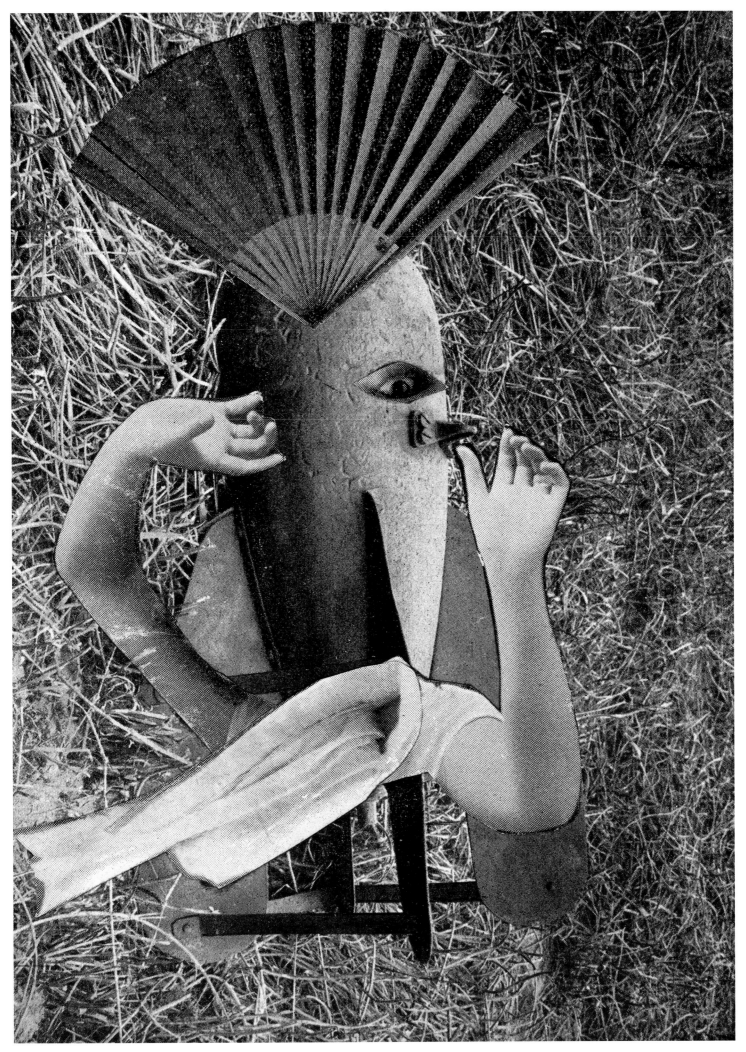

JOHANNES THEODOR BAARGELD

Le roi rouge (The Red King)

1920, pen and Indian ink on wallpaper, 49.2 x 38.7 cm
New York, The Museum of Modern Art, Purchase. 283.1937

b. 1892 in Stettin (today Sczcecin, Poland), d. 1927 at Mont Blanc

Dada in Cologne was always a two-man band, which grew into a triumvirate during the occasional visits of Hans Arp to the city. They worked together on various projects. Max Ernst and Johannes Theodor Baargeld were represented at the "First International Dada Fair" in Berlin in June 1920 among other work with the so-called *Simultantriptychon*. As early as February 1919 they had, according to Ernst's reminiscence, co-authored a number of contributions for "Ventilator". However, neither their names nor the term Dada appear in the magazine. Even so, the six issues which appeared in February and March 1919 are regarded as the first publication of the Dada movement in Cologne. It has since transpired that Baargeld financed the magazine, which attained a print-run of up to 40 000 copies.

Johannes Theodor Baargeld's real name was Alfred F. Gruenwald. In 1914 he had, like many of his generation, volunteered for military service, a decision he very soon bitterly regretted. The experience of war in the trenches formed the basis of his later political commitment. In 1918 he joined the left-wing worker's party, the U. S. D. P. (Independent Social Democratic Party of Germany), the next year the Dadaist movement.

Politics and art were for him the same thing. He hoped that his Dadaist protest against bourgeois society would further the movement for political renewal in Germany, a hope shared by some of the Berlin group. In fact, he came from an upper-middle-class background himself. His father was managing director of a re-insurance firm based in Cologne, the Kölnische Rückversicherungsgesellschaft. His parents were culturally open-minded, but politically conservative. It was because of his prosperous background that his friends called him Baargeld ("cash"). As a Dadaist he also bore the title "Zentrodada".

Le roi rouge (The Red King/Der rote König), dating from 1920, is one of the few pictorial works of Johannes Theodor Baargeld to have survived. It is a piece of wallpaper with a decorative pattern, drawn over in Indian ink. Baargeld employs the same pictorial principle as his fellow-Dadaist Max Ernst. An arbitrary starting material is treated, re-shaped and manipulated in such a way as to create a new reality. Here, the pen-stroke follows a few lines of the original structure, adds a few details in other places, and thus creates new links between the individual elements.

The result is a mechanical construction. Numerous screws can be discerned; from a flywheel in the middle, which Baargeld described as "Le curé" (the priest), the energy is transferred with the help of a rod to a further wheel. The neat inscriptions produce in the beholder a first impression that he is looking at the design for a piece of technical apparatus. To this extent it is a typical Dadaist theme, as pursued also by Max Ernst, George Grosz, Francis Picabia and Marcel Duchamp. It was also a gesture directed at the Expressionists, who in 1914 had, with such fateful enthusiasm, allowed themselves to be drawn into the alleged "communal experience" of the war.

"I have no pillow for my urn."
Johannes Theodor Baargeld

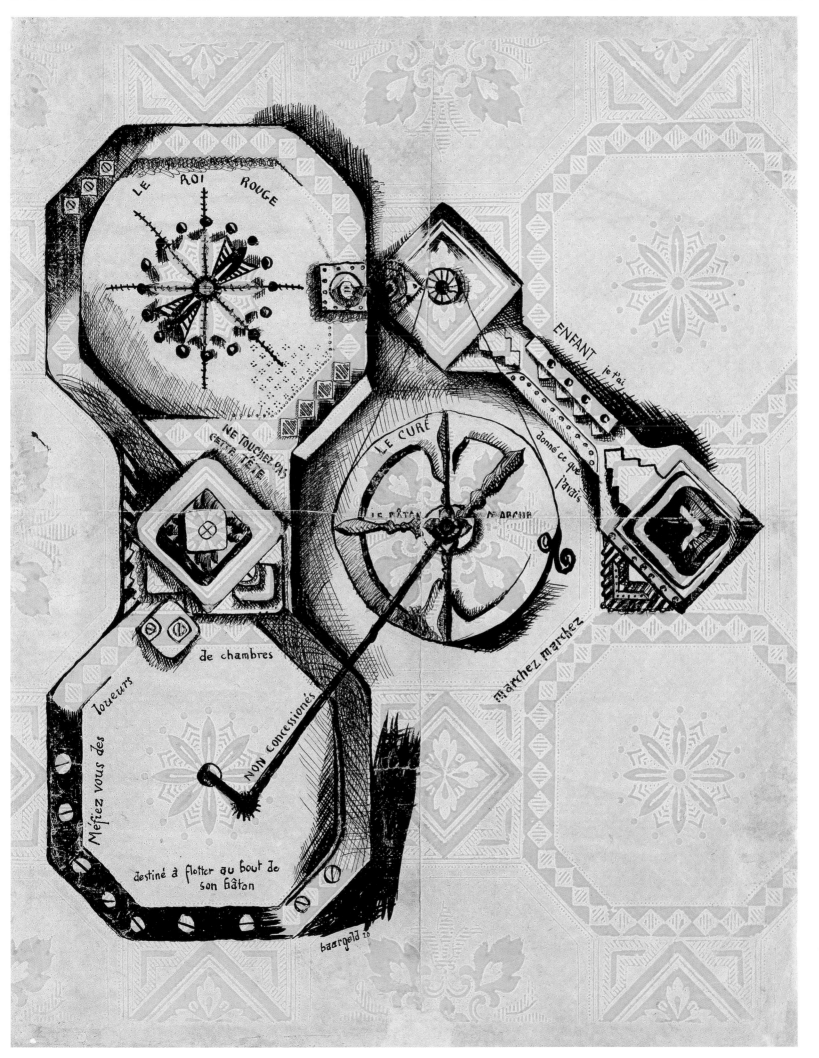

JOHANNES THEODOR BAARGELD

Venus at the Game of the Kings

1920, collage, 37 x 27.5 cm
Zurich, Kunsthaus Zürich

Max Ernst in later years recalled Johannes Theodor Baargeld – who as so often was creating a certain alienation by talking of himself in the third person – as saying: "When Max met him, they were both dada-ready, still numbed by the howl of war and sickened by its causes. Baargeld had a clear head and an ice-cold intellect, a fiery heart full of curiosity, impatience and lust for life. A solid education (Oxford), all-round knowledge. Outraged at the status quo, the root of all evil, enthusiastic for what is appearing, the source of all joys. Thus twofold action: political (although he is doubtless aware of the madness of such an enterprise) and poetical, in the only way possible at the time, namely desperate affirmation of life in work and behaviour."

Poetic qualities are evident above all in his artistic works; here he was in no way a provocative activist against the conservative bourgeoisie from which he came. After the politically combative "Ventilator" was banned in March 1919, the movement's subsequent publications were marked very much more by Dadaist irony, nonsense and playfulness.

His 1920 collages are larded with erotic allusions. In the picture *Vulgar misrepresentation: Cubic transvestite comes to an alleged parting of the ways* (whereby the German expression *Scheideweg* "parting of the ways" or "crossroads" could also be interpreted as "vaginal path") he places two of the cubic bodies in front of the seated figure in such a way that they form a monstrous phallus. The same is true of *Venus at the Game of the Kings (Venus beim Spiel der Könige)* which dates from the same year. In this work, Johannes Theodor Baargeld has taken various pictorial sources and put them together in such a way as to derive three altogether peculiar bodies. The centre of the picture is taken up by a black rectangle with amorphous white shapes, in which various kinds of fruit are arranged. Baargeld has taken a picture of a much bemedalled officer, cut it apart in the face and stuck it over, and under, the black area. Next to it is the head of a young woman. The amorphous shapes adjoin the three figures exactly, producing the impression that these bodies are growing directly from the heads. Baargeld has in addition emphasized the fruits with Indian ink and placed them in the white shapes in such a way as to make them look like female genitalia. He had already carried out this kind of re-interpretation by cutting out or re-touching in his work *The Red King*; later Max Ernst in particular raised the technique to the status of the design principle for his Surrealist works.

The *Venus at the Game of the Kings* attempts to cover her pudenda. The man by contrast, and this impression veritably forces itself on the beholder, seems to have nothing in his head apart from the distorted image of a naked female body. The depiction of the officer and the allusion in the title to war ("the game of kings") cryptically formulate a theme which was to be of central importance for art in the young Weimar Republic. In many artistic depictions, violence and sexuality became the symbol of a society that had lost all inhibitions, a society seeking to repress the early warning signs of the next catastrophe.

Following the scandal-laden exhibition at the Winter tavern in Cologne, Johannes Theodor Baargeld gradually withdrew from the Dadaist movement. As early as autumn 1920 he resumed his law studies at Cologne University, and by the time he came to write a short *curriculum vitae* in 1923, he was denying any association with the Dada movement, listing the years in question as devoted to "private study".

**"Love on a bicycle
is true love of one's neighbour."**

Johannes Theodor Baargeld

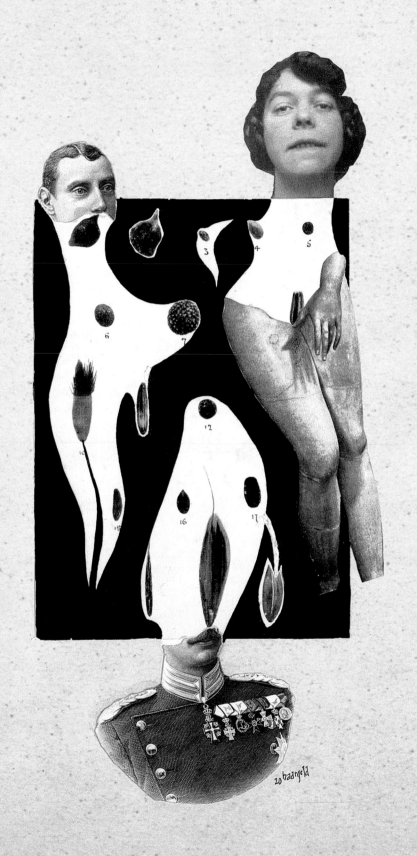

Fountain

1917/1964, porcelain urinal, 33 x 42 x 52 cm
Stockholm, Moderna Museet

**b. 1887 in Blainville,
d. 1968 in Neuilly-sur-Seine**

This work by Marcel Duchamp revolutionized art like almost no other. He was indisputably the most influential artist of the 20th century. Through the invention of the ready-made, Duchamp succeeded in demolishing the dominance of painting over sculpture. Whole generations of young artists, above all in the 1960s and 1980s, would swear by him, basing their own work on his fundamental concept. Marcel Duchamp studied at the renowned Académie Julian and developed into a highly successful painter. Even so, he always remained sceptical where the potential of painting was concerned. It did not satisfy his demands regarding the objectivity and scientific character of art. Thus, for Duchamp, painting could be "only one means of expression among others", as he himself once put it.

Finally in 1915 Duchamp gave up painting almost entirely. Two years earlier, his first ready-made had already made its appearance. It was a stool on which a bicycle wheel had been mounted. In 1915 Marcel Duchamp left France for New York. Here he entered his most provocative object, to which he had given the quite neutral title *Fountain*, for the annual exhibition of the Society of Independent Artists.

Ready-mades are a new autonomous artistic genre invented by Marcel Duchamp. They are industrially produced utilitarian objects, which achieve the status of art merely through the process of selection and presentation. Duchamp did not design these works, but designated objects he had found as works of art by definition. In so doing, he poured a bucket of cold water on the traditional myth of the artist as a creator of genius. He was interested instead in a rupture with conventional public expectations of art, in the limits of what constitutes a work of art, and in their radical extension. All his ready-mades pose a fundamental question: what are the characteristics and conditions that define an object as a work of art? Marcel Duchamp tried to answer this question for himself in as exact terms as possible. *Fountain* is an industrially produced urinal, to which the artist has made three changes in order to raise it to the status of a work of art: 1. he has placed it on a base or plinth; 2. he has signed and dated it; and 3. he has entered it for an exhibition of contemporary art. There was supposed to have been no jury for this exhibition, but the work was rejected nonetheless: this rejection confirmed the aesthetic explosiveness of his concept.

Duchamp's approach assumes that any object whatever can be declared to be art by being equipped with the characteristic attributes of a work of art. In our example, the first of these was the plinth, which treats the urinal as though it were a sculpture, makes it stand out from its surroundings and ennobles it. The inscription "R. Mutt 1917" designates the object as a work of art, because it now has a signature. Marcel Duchamp deliberately did not use his own name, but rather a pseudonym, because for him the signature was an artistic gesture: he was interested in the resulting claim of the object to be a work of art. Finally the object was to be presented to the public at an established art exhibition. Duchamp recognized that an object is defined first and foremost by its context and is perceived differently in different environments. His pioneering achievement for art was to point to the importance of this context for the evaluation of a work of art.

**„I tell them that the tricks of today
are the truths of tomorrow."**
Marcel Duchamp

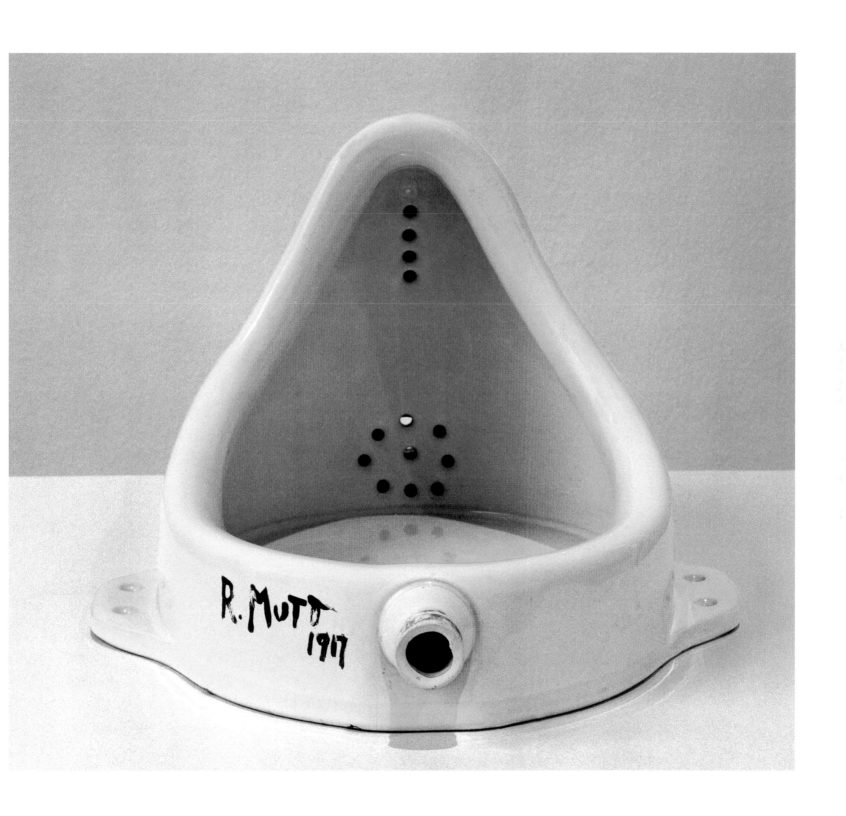

MARCEL DUCHAMP

L. H. O. O. Q.

1919/1930, pencil on a reproduction
of the Mona Lisa, 19.7 x 12.4 cm
Private collection

The Dadaists recognized their own concept of anti-art in Marcel Duchamp's ready-mades. But unlike the movement in Zurich, Duchamp was not rebelling against art as such. He was not concerned to destroy art or to make it ridiculous. Instead, he wanted to pose new, previously unasked questions about art. For him, the possibilities of traditional painting had been exhausted, while the border regions of art had not been explored.

At the moment when Marcel Duchamp opened up the art business to utilitarian objects such as a bottle-rack or his *Fountain* urinal as ready-mades, the aesthetic standards, judgements and mechanisms of the business came under the spotlight. At the same time, he broke with the romantic creator-myth by demonstrating that *objets trouvés* and mass-produced everyday functional objects could also be raised to the status of works of art simply by definition as such. On the other hand, precisely in so doing, Marcel Duchamp once again confirmed the artist myth, because it was for himself as artist that he claimed this extraordinary ability and authority. For the banal object only became a work of art because it was an artist who said so. Ten years later Kurt Schwitters made the same point even more exclusively: "Everything an artist spits out, is art."

Marcel Duchamp's presentation of everyday objects as works of art provoked New York exhibition-goers, who were accustomed to traditional paintings and sculptures. The art scandal was a typical Dadaist strategy. His disrespectful treatment of one of the icons of painting, Leonardo da Vinci's *Mona Lisa* (c. 1503–1506), also moved Duchamp closer to the European Dada camp. The picture dates from 1919 and consists of a postcard-size colour reproduction of Leonardo's painting, on which Duchamp has made some pencil alterations. Thus he has provided her with moustache and goatee beard, and below the picture itself added the mysterious sequence of letters "L. H. O. O. Q.". For Marcel Duchamp, such works also confirm his concept of the ready-made, even when the material – as here – is interpreted by him in the form of tendentious interventions. Duchamp treated the sublime values of art history with the same sort of disrespect as other Dadaists. Thus Kurt Schwitters stuck ironic quotes over a reproduction of the *Sistine Madonna* by Raffael (c. 1513/14) in 1921. The year before, Grosz and Heartfield had mounted the face of Raoul Hausmann on to a photo of the painter Henri Rousseau. And the Cologne Dadaist Johannes Theodor Baargeld likewise put his own head on a picture of the marble bust of a Classical female nude.

Marcel Duchamp was pursuing the same sort of humorous gender-bending as Baargeld by giving his Mona Lisa a beard. In the art literature, this gesture is continually interpreted as a hint by the Dadaists at speculations regarding Leonardo's (homo-)sexuality. Marcel Duchamp's work of this period is indeed full of sexual allusions, both open and concealed. These include the seemingly nonsensical letters "L. H. O. O. Q." If they are read quickly and in French, they produce the phonetic equivalent of the sentence: "Elle a chaud au cul", in other words, literally, "She has a hot arse" or figuratively, "She's a scorcher". A cryptic and at the same time somewhat coarse joke on Duchamp's part at the expense of the woman on Leonardo's untouchable masterpiece.

"I have forced myself to contradict myself in order to avoid conforming to my own taste."
Marcel Duchamp

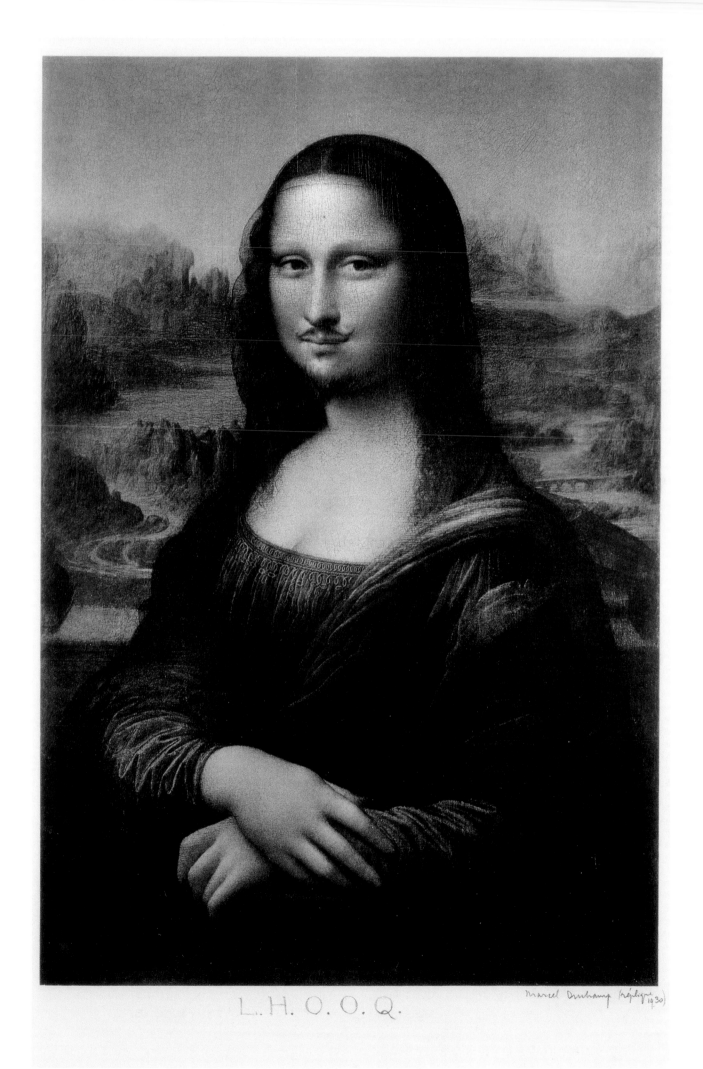

L . H . O . O . Q .

Marcel Duchamp (réplique 1930)

Marcel Duchamp as Rrose Sélavy

c. 1920/21, photograph by Man Ray, 21 x 17.3 cm
Philadelphia, Philadelphia Museum of Art,
The Samuel S. White 3rd and Vera White Collection

Like the reproduction of the *Mona Lisa* with its pencil additions, the photograph *Rrose Sélavy*, dating from 1920/21, also plays with gender roles. And once again, the title conceals an erotic word-play. The photograph shows Marcel Duchamp disguised as a woman. In a fashionable hat, elegant fur stole, eyes and lips conspicuously made up, and a ring on his left hand, he presents himself here as a lady from New York's high society. His artist friend Man Ray photographed Duchamp in the role of "Rrose Sélavy" in 1920/21.

Duchamp adopted this female identity on a number of occasions, including another photograph portrait by Man Ray. If we compare the two pictures, the earlier one, dating from 1920, comes across as a still imperfect preliminary draft or sketch for the later. With a hat drawn down over his face, a conspicuous wig and shawl pulled around him, the artist comes across here more as an actor in some amateur costume drama. This pose and the elegant appearance in the 1920/21 photograph are indeed worlds apart.

In Marcel Duchamp's self-portrait as "Rrose Sélavy" there are no longer any clear boundaries between the sexes. The male artist is not only slipping into an alien role, but is adopting a female identity. The name of his female *alter ego* is at the same time a cryptic commentary on his total artistic œuvre, laden with numerous sexual motifs. If we give the name "Rrose Sélavy" its French pronunciation, we can also interpret it as "Eros, c'est la vie" (Eros, that's life). In an interview in 1966, Marcel Duchamp openly admitted: "I believe very strongly in eroticism, because that's really a pretty universal thing the world over, something that people understand."

Duchamp's game with his own sexual identity reflects the uncertainty of an unambiguous position, as we see in many of his artistic works. Above all his ready-mades focus on this sudden change from one context to a very different one, in that they can be either utilitarian objects or works of art. Without themselves changing, they are assessed in different ways, depending on where they are and with what expectations the beholder perceives them.

The earlier "Rrose Sélavy" motif was used by Marcel Duchamp in 1921 as a sticker for a perfume bottle he had designed, which he called *Belle Haleine. Eau de Voilette*. As a company logo, the label bears the inscription "RS, New York – Paris", the Rrose Sélavy monogram. Duchamp packed the glass bottle in an elegant box. With this home-produced ready-made, Marcel Duchamp – presumably unwittingly – was reforging a link with the origins of Dada in Zurich. Alongside the well-known legends surrounding the vehemently defended claims of individual Dadaists to have invented the term Dada, there is one more possible source for the word. Since as early as 1906, the Zurich firm of Bergmann & Co. had been manufacturing a toilet water advertised as strengthening the hair. The name of this miracle product was simple and pithy: DADA.

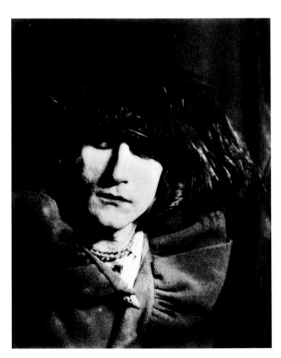

Man Ray, Marcel Duchamp as Rrose Sélavy, 1920

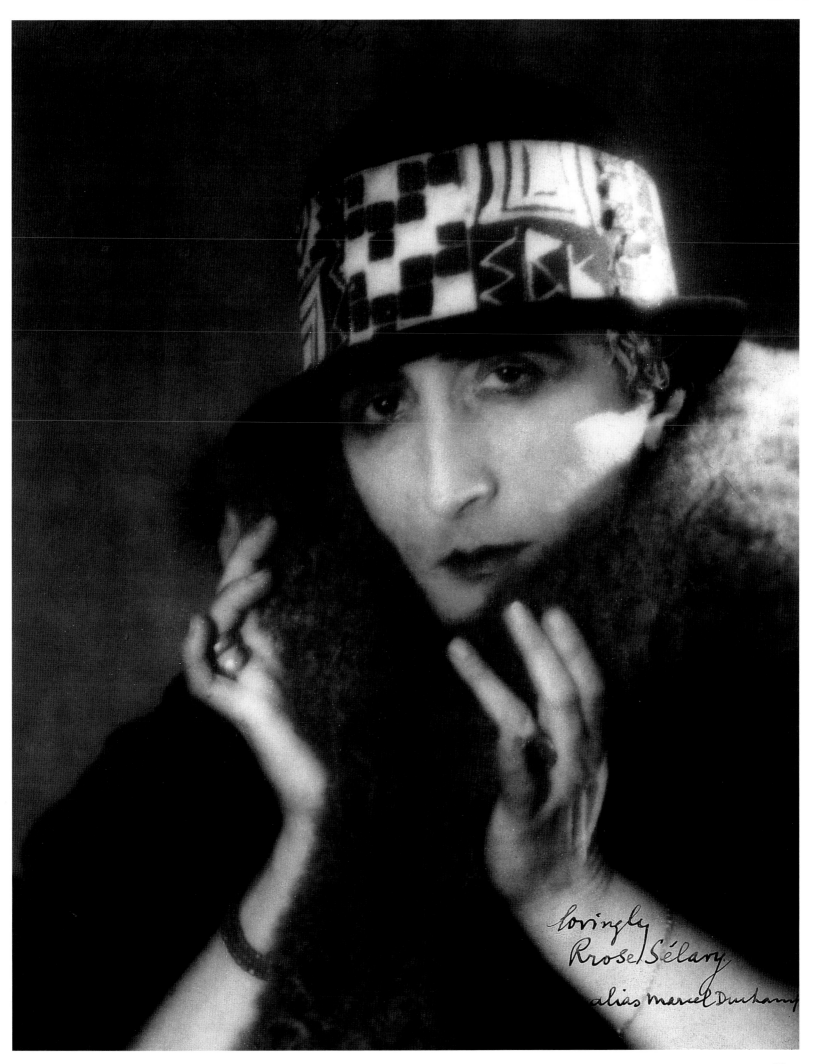

*lovingly
Rrose Sélavy
alias Marcel Duchamp*

Clothes Stand

1920, photograph of a sculptural collage, 25 x 16.5 cm
Zurich, Kunsthaus Zürich

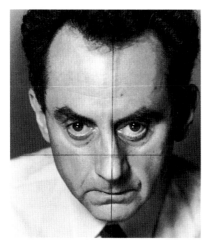

b. 1890 in Philadelphia, d. 1976 in Paris

Man Ray was born Emmanuel Rudnizky in Philadelphia and grew up in New York. At the age of 24 he assumed his pseudonym. The surname, with its allusion to light, seemed to be a prophetic reference to his future career as a photographer. At this time, however, Man Ray was still devoting himself exclusively to painting. He was a regular guest at Alfred Stieglitz' gallery 291, had visited the "Armory Show" in 1913 and in 1915 had become friends with Marcel Duchamp. Together with the art-collector Katherine S. Dreier, they initiated the Société Anonyme in 1920, New York's first museum of contemporary art. The famous Museum of Modern Art in New York was similarly founded on private initiative, albeit nine years later.

Marcel Duchamp's works were an important source of inspiration for Man Ray. The decisive artistic step came in 1916, when he liberated his art from the traditional form of painting with a paintbrush. With the airbrush, Man Ray adopted a creative technique with which he was able to achieve a more technical and more anonymous expression of his motifs than was possible with traditional painting in oil on canvas. The resulting technique he called "aerography": "I was looking for something quite new, something for which neither easel nor brush nor any of the equipment of a traditional painter was needed."

Man Ray used stencils and applied the paint with a spray-gun. He was fascinated by the mechanical character of the work-process, which left no individual or gestural brush-stroke on the picture surface. In this sense, his interest in the more technical process of photography, which he took up professionally at the latest on his arrival in Paris in 1921, was only logical. In this genre too, Man Ray enjoyed experimentation. He worked with the solarization technique and re-discovered how to create photographs without a camera, by laying various objects direct on light-sensitive paper and exposing them to light. With great self-assurance, he called the results "rayographs".

The *Clothes Stand* of 1920 is an early work, unusual for Man Ray, but perhaps precisely for that reason one of his typical Dadaist works. At first sight it seems to be a collage. In fact he staged the motif and then photographed it. A nude female model is hiding behind a kind of clothes-stand, which consists of an open base and a vertical metal rod, to which, cut out of cardboard, the outlines of head, shoulders and arms have been attached. The hair, eyes, and mouth are drawn on the cardboard. Man Ray has left the surroundings entirely black, so that the beholder has no spatial orientation.

As a result there is close fusion between the female body and the doll-like construction. The two unite to form a new being. Similar *manichino*-figures in the Italian Pittura metafisica paintings of Giorgio de Chirico had been models not only for Man Ray, but also for the Dadaists in Berlin and Cologne. The hybrid of human being and machine was a topos in the 1920s when modern was the thing to be and everyone believed in progress, and it was present in one form or another in every artistic genre. It is no coincidence that the artificially created woman in Fritz Lang's 1927 masterpiece "Metropolis" resembles the female figure staged and photographed by Man Ray in 1920.

> "I photograph the things
> that I do not wish to paint, the things
> which already have an existence."
>
> **Man Ray**

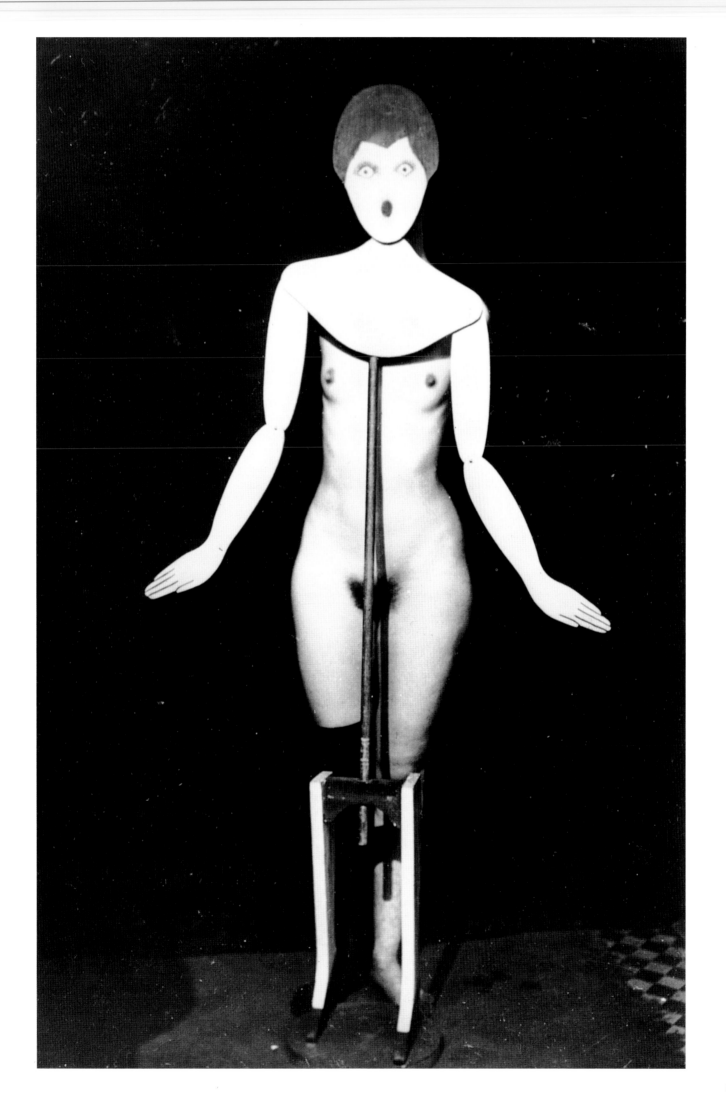

Gift

1921/1940, flatiron, nails, 15.3 x 9 x 11.4 cm
New York, The Museum of Modern Art,
James Thrall Soby Fund. 1966

Gift (Cadeau) is Man Ray's best-known object. It dates from 1921 and timewise stands on the cusp of his artistic development from New York Dadaism to being one of the central figures in Parisian Surrealism. The work has, however, often been described as an altogether typical object in the spirit of Lautréamont's definition of Surrealism.

For this assemblage, Man Ray took an iron and stuck fourteen copper nails to its underside. Following Lautréamont's description of the chance confrontation of a number of objects from different areas of life in an alien situation, for which he adduced the example of an umbrella and a sewing-machine on a dissecting table, we could here speak of the encounter between flatiron and nails, which must surely appear to the beholder as equally nonsensical, illogical, in fact surreal.

However, what we have here is not the confrontation of two mutually alien objects. Man Ray does not allow the materials to retain their own identity, but uses the combination to create an entirely new object, unknown in this form, a mutation of the familiar and useful flatiron. Precisely because the object loses its practical purpose, we have an irredeemable conflict between the functionality of the object and the failure of its function. It is at this point that the attention of the beholder comes to focus on the ironic and Dadaist potential of the work *Gift*.

Man Ray had already related another object to the poet Lautréamont, whose real name was Isidore Lucien Ducasse. In 1920 he had created *The Enigma of Isidore Ducasse*, a mysterious object which Man Ray had tied up in a thick sackcloth blanket. It was irregular in shape, with a number of bulges, which however did not permit the enclosed object to be identified. In fact Man Ray had packed Lautréamont's famous sewing-machine together with an umbrella and thus alienated both.

The two objects, incidentally, were soon destroyed, and have only survived in the form of Man Ray's own photographs. Later the artist made several replicas of *Gift* and produced a limited edition (1940), albeit of 5,000, an unusually large number (with thirteen nails). This *Gift* however is a deceptive one, disappointing its recipient because it does not fulfil its domestic purpose. The pointed nails would tear the material if ever an attempt was made to use the iron for

its usual purpose. In fact however it is worth very much more, because it has a playful value and a value between friends. Marcel Duchamp "defined" Man Ray that same year, 1921, in this spirit as though he were a dictionary entry: "Man Ray, masculine, noun, synonymous with: pleasure in play, enjoyment."

The Enigma of Isidore Ducasse, 1920

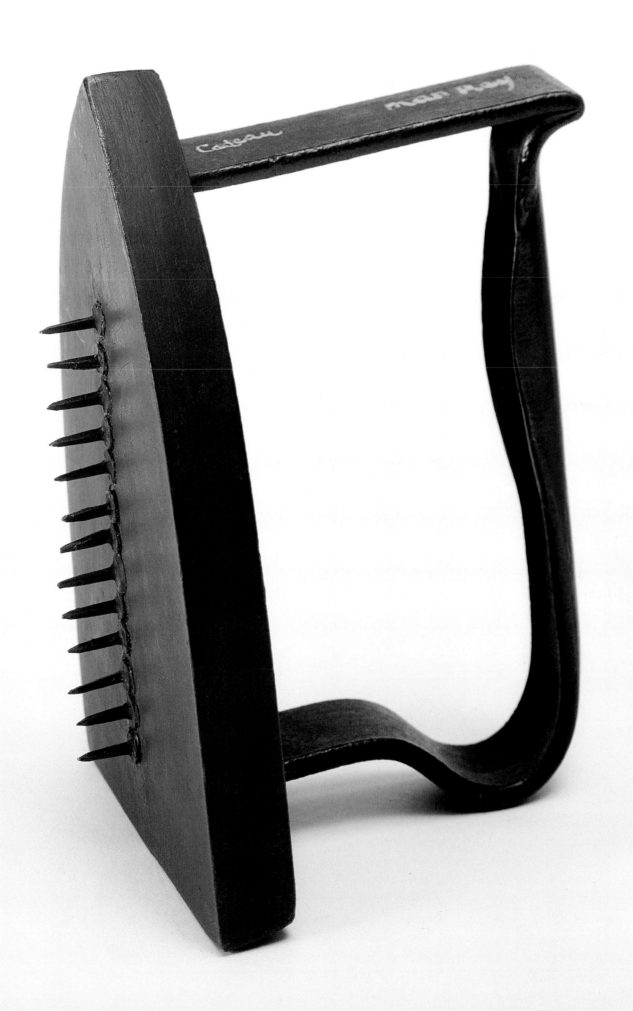

FRANCIS PICABIA

Love Parade

1917, oil on cardboard, 96.5 x 73.7 cm
Private collection

b. 1879 in Paris, d. 1953 in Paris

Francis Picabia was the scion of a prosperous family from Cuba. Financially independent, he was an amateur painter in the true sense of the word, that is to say, he painted out of a love for painting. His second great passion was for fast cars. In 1913 he was the only French artist to be able to afford the expensive trip to New York for the opening of the "Armory Show". He himself was represented at the exhibition with three works. It was in New York in June 1915 that Francis Picabia began to compose the first symbolic machine pictures. The theoretical concept behind these works was formulated by Paul Haviland in the September issue of the magazine "291", in which he wrote: "We are living in the age of the machine. Man made the machine in his own, image. She has limbs which act; lungs which breathe; a heart which beats; a nervous system through which runs electricity. The phonograph is the image of his voice; the camera the image of the eye. The machine is his 'daughter born without a mother.'" That same year, Francis Picabia dedicated one of his machine portraits to the poet in the form of an electric table-lamp, to which he had added the inscription: "La poésie est comme lui."

The format, the complex execution and the use of colour make the *Love Parade (Parade amoureuse)*, which dates from 1917, the central work in this series of machine motifs. As with many other Dadaist works, here too the artist has integrated the title into the picture. This creates a certain distance between the beholder and the work, thus preventing any emotional approach to the motif. The same purpose is fulfilled by the artless execution, which dispenses with any painterly gesture and instead prefers purely objective, technical and anonymous brushwork. The title of the work, however, suggests an erotic motif, which seems, then, to irredeemably contradict the constructivist depiction. For surely a "love parade" has different associa-

tions for most beholders. However, and this is true also of this work by Francis Picabia, many Dadaist works have similar subliminal erotic components, which, often articulated precisely in such mechanical depictions, suppress any subjective element.

In this large-format work, Francis Picabia has placed the apparatus of the *Love Parade* in a closed space. On closer inspection, the machine turns out to be composed of two elements, one grey and one coloured, which are connected by rods. The two parts can be identified as the male and female elements in this "love parade". The grey structure consists of two upright cylinders, in which a thin rod, divided at its lower end, moves rhythmically up and down. This construction can be interpreted as the male sexual organ. Its strength and dynamism are transferred via a complicated system of rods with a number of screw-threads to the coloured apparatus on the right. This is the female counterpart to the grey shape. The central element in this machine is the vertical brown piston, which rhythmically penetrates the green (female) vessel. Picabia's machine image is in fact an ironic commentary on and a symbol of the role of the sexes in a modern industrial society.

**"DADA talks with you,
it is everything,
it includes everything,
it belongs to all religions,
can be neither victory nor defeat,
it lives in space and not in time."**

Francis Picabia

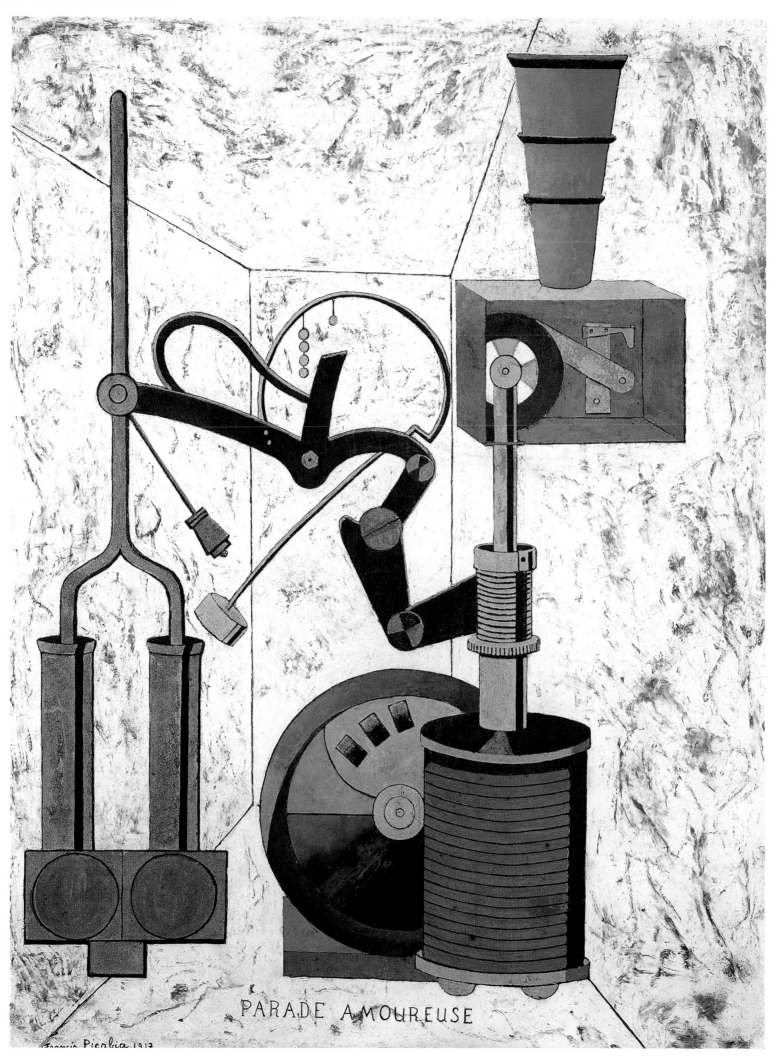

PARADE AMOUREUSE

Francis Picabia 1917

Dada Movement

1919, pen and Indian ink on paper, 91 x 73 cm
New York, The Museum of Modern Art, Purchase. 285.1937

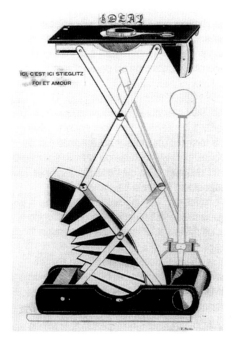

**Here, This Is Stieglitz/
Faith and Love, 1915**

The "Armory Show" 1913 in New York became a huge *succès de scandale* largely thanks to the presentation of Marcel Duchamp's large-format painting *Nude Descending a Staircase*.

Duchamp and Francis Picabia had been linked by a close artistic friendship since their first meeting in Paris in 1910. It was through Duchamp that Picabia made the acquaintance in 1913 of the New York photographer and gallery-owner Alfred Stieglitz. Picabia's art derived decisive impetus during this sojourn. He was fascinated by the achievements of American engineering. He admired the city's architecture and bridges. This fascination, together with his enthusiasm for the latest and increasingly fast automobiles, provided him with the impulse to develop his so-called machine pictures.

One of the first of these was *Here, This Is Stieglitz/Faith and Love,* which dates from 1915, during his second trip to New York. Already on his first trip two years earlier, Stieglitz had devoted an exhibition to him in his Little Gallery of the Photo-Secession. Now Francis Picabia was able to repay him in the form of a portrait, albeit one lacking in any individual features; the sitter is identified only symbolically, by means of a folding camera. Picabia is here adapting the style of technical drawings. His picture evinces the same reduced, precise and anonymous character, without however fulfilling their function as a blueprint for some construction or other.

Francis Picabia's drawing *Dada Movement (Mouvement Dada)* dates from 1919 and shows in schematic form the artistic energy supply for the magazine "391", represented by the numerals at the bottom right-hand edge of the picture. Picabia had published the first issues in Barcelona in 1917 and continued the magazine later in New York. Its title is an allusion to Stieglitz' own magazine "291", which in turn took its name from the address of the gallery in New York: 291, Fifth Avenue. In the drawing, two batteries supply power to a machine with a time-switch. To them are assigned the names of artists like Cézanne, Matisse, Braque, Picasso, and Picabia himself, as well as the inscription "Mouvement Dada". Alongside, arranged as though on a clock-face we see among others the names of the Dadaists H. Arp, Stieglitz, Tr. Tzara and M. Duchamp. At a particular point in time, suggests the drawing, the time-switch will release a stream of energy and channel it to the element with the inscription "391". This latter object is a bell. The magazine "391", in the view of Picabia as expressed in the idea of the "Dada Movement" depicted in this drawing, was to act as an alarm-bell to awaken the people of Paris and New York to Dadaism.

**"Dada is like your hopes: nothing
like your paradise: nothing
like your idols: nothing
like your heroes: nothing
like your artists: nothing
like your religions: nothing"**

Francis Picabia

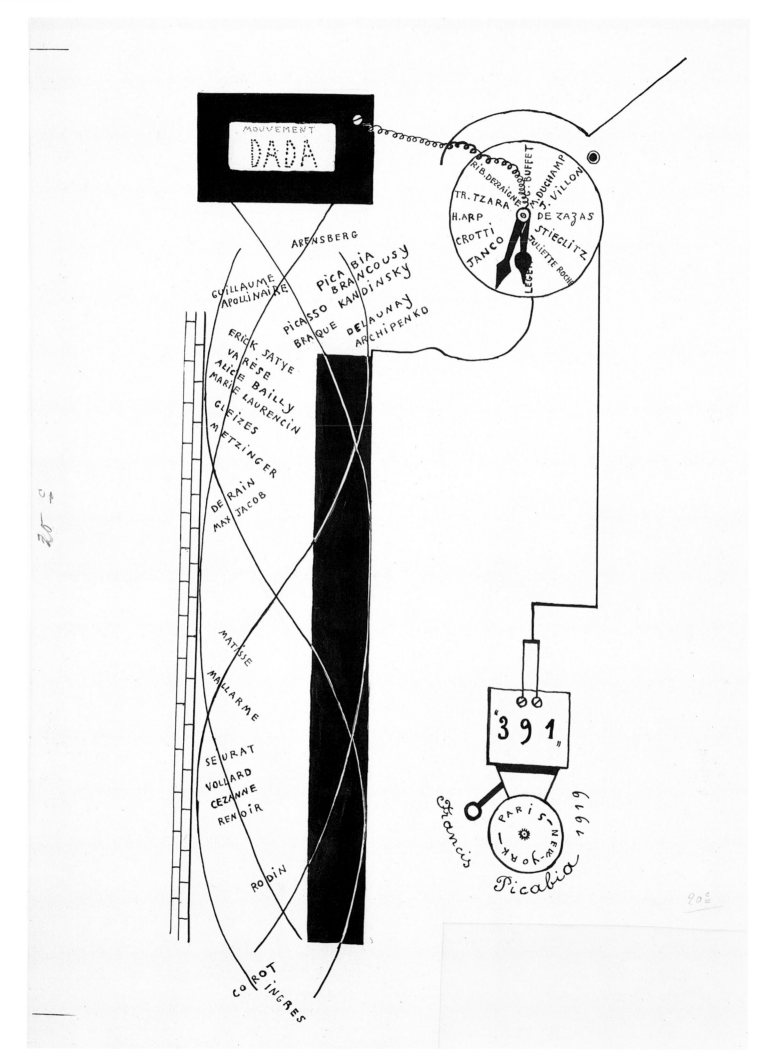

Beware: Painting

1919, oil, enamel and gloss-paint on canvas, 91 x 73 cm
Stockholm, Moderna Museet

Francis Picabia's magazine "391" carried the message of Dada New York across the Atlantic and the front-lines of the belligerent powers all the way to neutral Switzerland. In his literary collection published in 1961, "Dada Profile", Hans Richter recalled: "With 391 our panorama extended by as many degrees. The magazine of that name was for us in Zurich like a mirror, in which the extent of the transformation in art that we were seeking was reflected. The New Yorkers felt and thought like us, or even more so, as we realized. The new lack of preconditions was therefore general." Alongside this magazine, Francis Picabia's machine pictures made the central contribution to the international Dada movement.

The first examples of these machine pictures appeared as early as 1915, in other words a few months before the actual foundation and naming of the movement in Zurich. And if these works are anti-art, then it was in a quite different sense from that employed by the Zurich and Berlin Dadaists in respect of their own work. Picabia's machine pictures are a statement against traditional painting and derived from a desire to find an aesthetic expression in painting for the modern age of the engineer. The fact that he gave his friendship-portraits the outward form of technical drawings seemed in accord with the typically nihilist or satirical attitude of the Dadaists. His works of this period, like those of Man Ray and Marcel Duchamp, are nevertheless proof of the international integrative force which the Dadaist movement, in spite of internal power struggles, was able to unleash.

Beware: Painting (Prenez garde à la peinture) dates from 1919 and is an ironic commentary on traditional established painting. Francis Picabia was setting up an alternative model to the standard idea of the creative process, according to which a work of art materializes by dint of the creative power of its creator. His picture centres on a cylinder shown in cross-section, so that the beholder is permitted to see into its interior. The lower part of the object bears the inscription "Dieu brouillon", as though the apparatus served to produce divine inspiration. On the right, two thin lines connect the cylinder with a circular area, in which there is nothing but the two words "Domino" and "Celeste". On the left, a line runs across a number of wheels back to the cylinder. Each of these little wheels carries an inscription: "Lyrisme", "Folle" and "Biscotte". It is the lyrical and carnival element, even the fragment of rusk, therefore, that according to Francis Picabia constitute the power of artistic inspiration. They drive the piston in whose interior an initial ignition is triggered. The energy released at this moment is transferred to the disk at the right, where painting has a great deal of space to develop.

At the same time, Picabia's title for the picture *Prenez garde à la peinture*, in other words "Beware: Painting", is a warning in respect of this work, and could also be understood as an ironic commentary on the anti-art demands of his Dadaist friends in Zurich. Immediately before the picture was painted, in the winter of 1918/19, he had spent a while in Switzerland, where he had taken part in a Dada exhibition at the Kunsthaus Zürich.

**"Our heads are round
so that our thoughts can
change direction."**
Francis Picabia

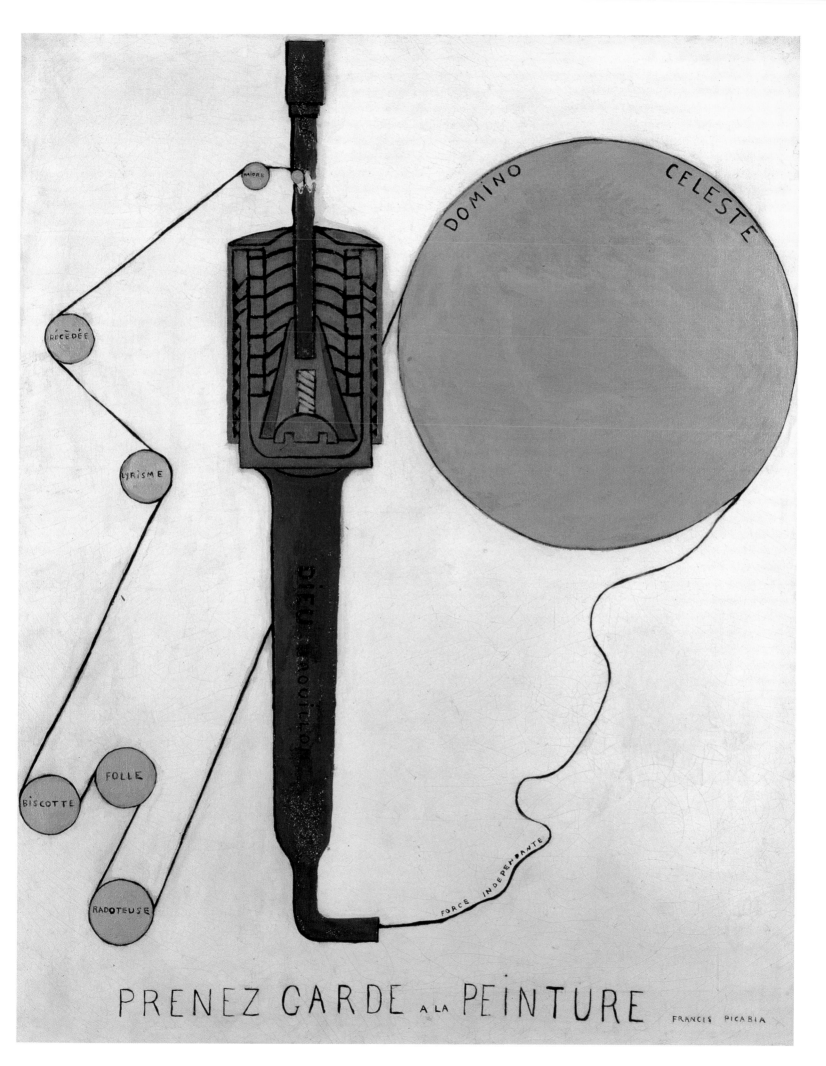

To stay informed about upcoming TASCHEN titles, please request our magazine at www.taschen.com/magazine or write to TASCHEN America, 6671 Sunset Boulevard, Suite 1508, USA-Los Angeles, CA 90028, contact-us@taschen.com, Fax: +1-323-463.4442. We will be happy to send you a free copy of our magazine which is filled with information about all of our books.

Reference illustrations:
p. 30: Hans Arp, *Rectangles Arranged According to the Laws of Chance (Rechtecke nach den Gesetzen des Zufalls geordnet),* 1916/17, collage, 33.2 x 25.9 cm, New York, The Museum of Modern Art, Gift of Philip Jonson. 496.1970
p. 40: Raoul Hausmann, *Poster poem "fmsb…",* 1918, collage, 33 x 48 cm, Private collection
p. 46: Hannah Höch, *High Finance (Hochfinanz),* 1923, collage, 36 x 31 cm, Private collection
p. 54: R. Sennecke, *"First International Dada Fair",* 1920, photograph, Berlin, Berlinische Galerie, Landesmuseum für moderne Kunst, Photographie und Architektur
p. 56: Johannes Baader, *Double portrait of Johannes Baader and Raoul Hausmann,* c. 1919/20, photoprint of a montage on newsprint, 25.4 x 15.8 cm, Zurich, Kunsthaus Zürich
p. 62: Kurt Schwitters, *Drawing A2 Hans (Hansi),* 1918, collage, 17.9 x 14.5 cm, New York, The Museum of Modern Art, Purchase. 96.1936
p. 64: Kurt Schwitters, *Construction for Noble Women (Konstruktion für edle Frauen),* 1919, assemblage, 103 x 84 cm, Los Angeles, Los Angeles County Museum of Art
p. 66: Kurt Schwitters, *Title-page of the "Merz" magazine No. 2 (i-number),* 1923, 22.4 x 14 cm, Hanover, Sprengel Museum, Kurt und Ernst Schwitters-Stiftung
p. 72: Max Ernst, *Dada-Degas,* c. 1920/21, collage, 48 x 31 cm, Munich, Pinakothek der Moderne
p. 74: Max Ernst, *the chinese nightingale (die chinesische nachtigall),* 1920, photograph, 14 x 9 cm, Hanover, Sprengel Museum, on loan from the Sammlung Nord/LB in der Niedersächsischen Sparkassenstiftung
p. 84: Man Ray, *Marcel Duchamp as Rrose Sélavy,* 1920, photograph, 13.8 x 9.9 cm, Paris, Musée National d'Art Moderne, Centre Pompidou
p. 88: Man Ray, *The Enigma of Isidore Ducasse (L'Enigme d'Isidore Ducasse),* 1920, photograph, 54.3 x 41 cm, Private collection
p. 92: Francis Picabia, *Here, This Is Stieglitz/Faith and Love (Ici, c'est ici Stieglitz/ Foi et amour),* 1915, collage and ink on paper, 75.9 x 50.8 cm, New York, Metropolitan Museum of Art

Page 1
MAX JACOB AND HANS ARP
"Dada 3" and "Der Zeltweg"
Title page "Dada 3", 1918, edited by Tristan Tzara and title page "Der Zeltweg", 1919, edited by Otto Flake, Walter Serner and Tristan Tzara

Page 2
GEORGE GROSZ
Republican Automatons
1920, watercolour, pen and Indian ink on cardboard, 60 x 47.3 cm
New York, Metropolitan Museum of Art

Page 4
RAOUL HAUSMANN
Dada-Cino
1920, collage, no dimensions available
Private collection